professionalphotography photographingbuildings

professionalphotography **photographing**buildings **david**wilson

RotoVision

contents

introduction

The built environment is as old
as human civilisation, and
magnificently diverse – and
there are as many different ways
of photographing it as there are
types of building. Whatever your
motivation – a professional
commission, shooting for stock,
the fine art market or simply for
fun – the field of architectural
photography offers innumerable
possibilities.

exteriors

The exterior of a building is its public face, but the way you approach it depends on your intended market. Sometimes a straight record shot is what is required, at other times you may aim to create a particular mood through lighting or choice of equipment. Night-time shots have their own special atmosphere.

technical details
Rolleiflex 6008 camera with a 150mm
Sonnar lens. Film was Fujichrome
Provia 100, with an exposure of
1/60sec at f/11.

Composition

Angelo Hornak owns a small speedboat, from which he took a series of photographs of London buildings up and down the River Thames. This nicely balanced shot of Canary Wharf was one of them. "The reflection was really as much the subject as the building, and I waited a long time for the moving water to settle so it was clearly visible," says Hornak. He used a 6x6cm Rolleiflex camera and a 150mm lens – roughly the equivalent of an 85mm telephoto in 35mm photography – which allowed him to get a good distance away from the building and still fill the frame. This approach works well on a bright day but is less effective when conditions are hazy.

Technique

As skipper of his own boat Hornak could choose the viewpoint he wanted, but he could do nothing to stop the craft bobbing up and down. In such conditions a tripod is useless, so he sat down and shot handheld, absorbing as much of the movement as he could with his body. He was able to use reasonably slow shutter speeds, but inevitably some frames were spoiled by camera shake. "Film is relatively inexpensive, but I wouldn't attempt this in rough weather," he says.

Lighting

Hornak took the picture at mid-day, when the light was quite harsh, but he felt this suited the harsh lines of the building. "It accentuated its sharpness," he explains. "It also increased the contrast between the bright white reflection and the dark water. In a way, that was the main interest."

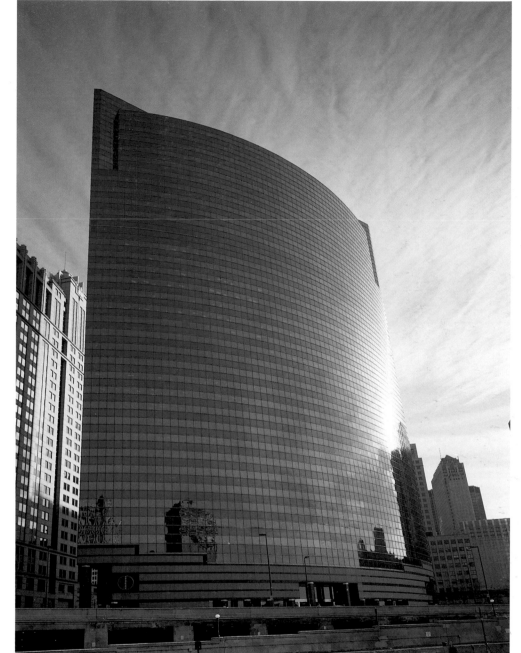

Coincidentally, Angelo Hornak also photographed this Chicago building from a boat, but this time from a moving vessel over which he had no control. He used a Corfield 6x7cm camera, which is especially designed for architectural photography, having a rising front that can be used to stop buildings 'leaning' (in a similar way to a perspective control lens on a 35mm camera). However, on this occasion it made little difference as he only had time for a quick grab shot, handheld. The Corfield camera comes with a fixed 47mm wide angle lens (which equates roughly to 23mm in the 35mm format).

technical details
Corfield WA67 camera with a 47mm Schneider Super Angulon lens. Film was Fujichrome Provia 100, with an exposure of 1/125sec at f/8.

Composition

Koen van Damme was commissioned by the architect to record this newly completed office building in Ghent in Belgium. As well as recording the different elevations of the building, his brief was to capture all the different materials used in its construction. Colour film, he calculated, would have proved a distraction, so he chose black-and-white to render the surfaces more abstract and to concentrate attention on their textures. A wide angle lens allowed him to create a dramatic composition.

Technique

The carefully chosen camera position, together with the use of monochrome film, had a further function: it disguised the fact that the development's garden area, yet to be laid out, was an unappealing patch of raw earth. Sometimes it is just as important to decide which elements of a scene to leave out as which ones to include.

technical details

Linhof Technikardan 6x7cm camera with a 45mm lens. Film was Ilford 100 Delta Pro, used in available daylight.

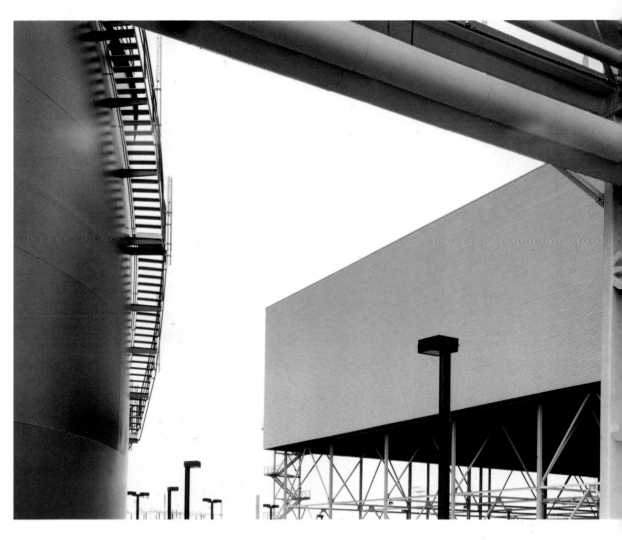

Composition

This power station was still under construction when Koen van Damme photographed it, and the site was messy and chaotic. He wanted to concentrate attention on the graphic shapes, and found this was best done by photographing from a relatively high vantage point. This angle gave him a powerful abstract image, with the various structures outlined against the sky. It also had the added benefit of allowing him to crop out the clutter on the ground, which would have diluted the impact of the picture.

technical details

Linhof Technikardan 6x7cm camera with a 90mm lens. Film was Ilford 100 Delta Pro, used in available daylight.

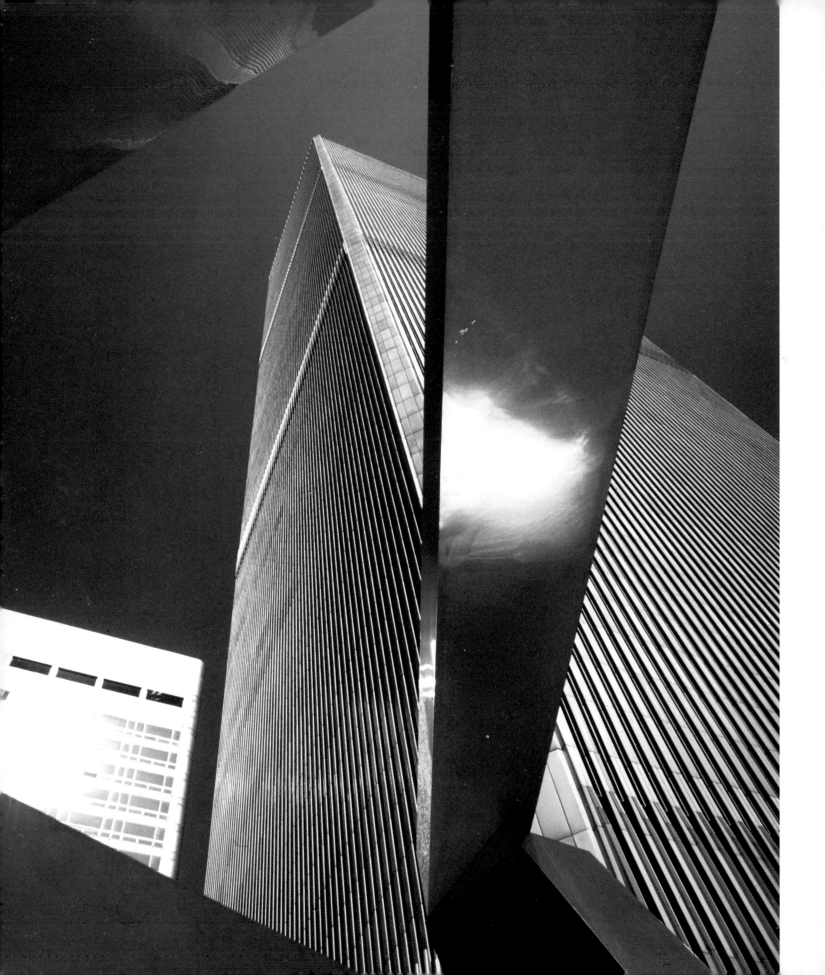

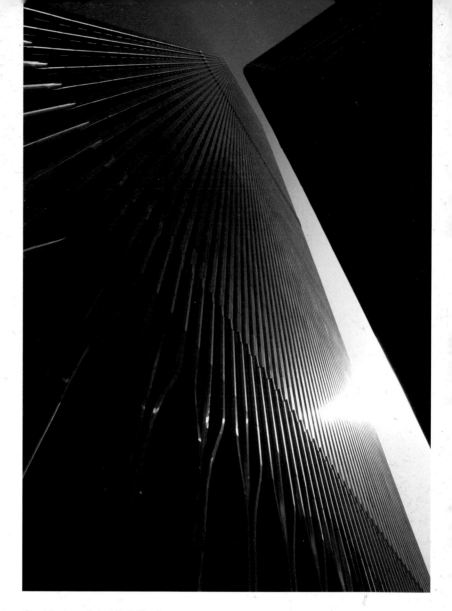

Composition

When Mario Guerra is shooting to an architect's brief, he can rarely give full rein to his creativity: clients normally want straightforward record shots. However, when he's shooting for himself he can let his imagination run riot. He draws his inspiration from modern urban architecture which, with its graphic shapes and reflective surfaces, lends itself well to abstract shots. For this study of the World Trade Centre in New York, he used a wide angle 24mm lens on a 35mm SLR and tilted the camera upwards, to accentuate the dizzying perspective.

Lighting

There was plenty of illumination, with bright sunlight reflecting off the steel and glass façades of the buildings. Guerra was able to select a fast shutter speed together with a relatively small aperture of f/11, which ensured that the different elements of the picture were rendered sharp, from the angular steel structure in the foreground to the topmost storeys of the tower.

technical details

Nikon 35mm SLR camera with a 24mm Nikkor lens. Film was Kodak Ektachrome 64, with an exposure of 1/125sec at f/11.

For this view of the World Trade Centre, Mario Guerra shot with a 24mm lens angled upwards and deliberately allowed the verticals of the two tower blocks to converge. He waited until early evening when the sun was low in the sky: its reflection in the shiny façade of the building gave the graphic triangular shapes a touch of drama.

technical details

Nikon 35mm SLR camera with a 24mm Nikkor lens. Film was Kodak Ektachrome 64, with an exposure of 1/125sec at f/8.

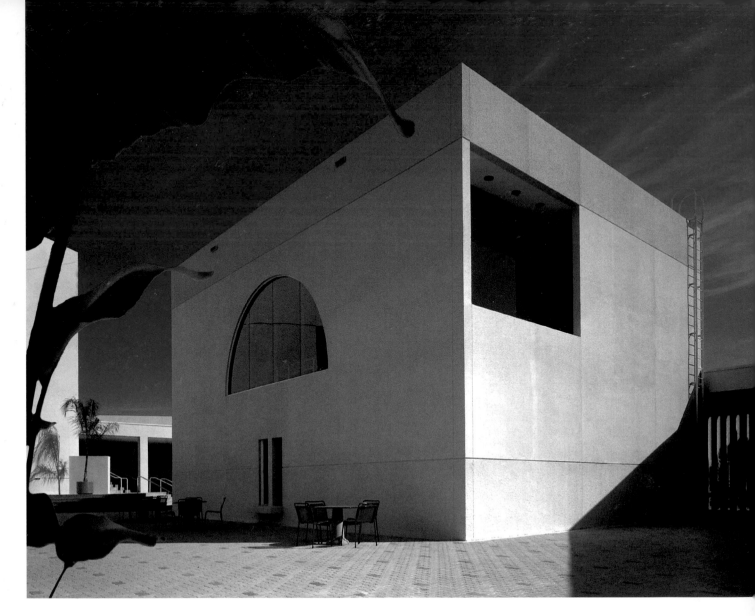

Composition

Surprise is one of the most effective weapons in the photographer's armoury. "Compositions should be easy to look at but graphically strong. Look for ways to surprise the viewer," says Mark Surloff. Commissioned to shoot this civic centre building in Florida, he used a combination of a wide angle lens and a low camera angle to give the structure a monumental feel. The foliage in the foreground helped to exaggerate the perspective.

Technique

A solid tripod held the camera firmly in place and allowed him to frame precisely. The best tripods are both rigid and flexible. "Use a heavy-duty model that allows a relatively high vantage point – 6ft or higher – and, just as important, allows a very low angle of view," advises Surloff.

Lighting

Surloff was working in available morning daylight, but waited until it had lost its early warmth so that the concrete would be rendered a 'cleaner' grey. He used a polarising filter set to maximum rotation to deepen the colours, especially the blue of the sky, and shot from the shadow side of the structure. "Very often the best camera position is on the shadow side – it tends to define shapes better," he explains.

technical details

Sinar Standard 5x4in camera with wide angle bellows and a 120mm Schneider Angulon lens. Film was Fujichrome 100, used with a polarising filter, and the exposure was 1/15sec at f/32.

Sometimes the vision of the architect makes the photographer's job a relatively easy one. "This colourful and contemporary elementary school has a multi-spatial, multi-layered design that inspires the best work from any photographer," says Mark Surloff. He shot it with a standard 150mm lens on a 5x4in camera, and used a polarising filter to increase contrast in the blue sky and the white walls.

technical details
Sinar Standard 5x4in camera with wide angle bellows and a 150mm Schneider Symmar lens. Film was Kodak Ektachrome 100, used with a polarising filter, and the exposure was 1/15sec at f/32.

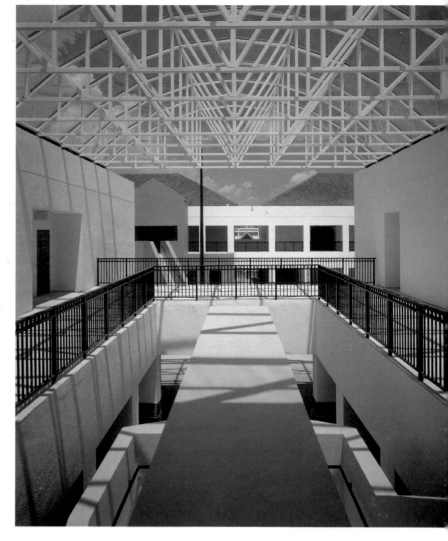

"Very often the best camera position is on the shadow side of the structure – it tends to define shapes better."

Mark Surloff

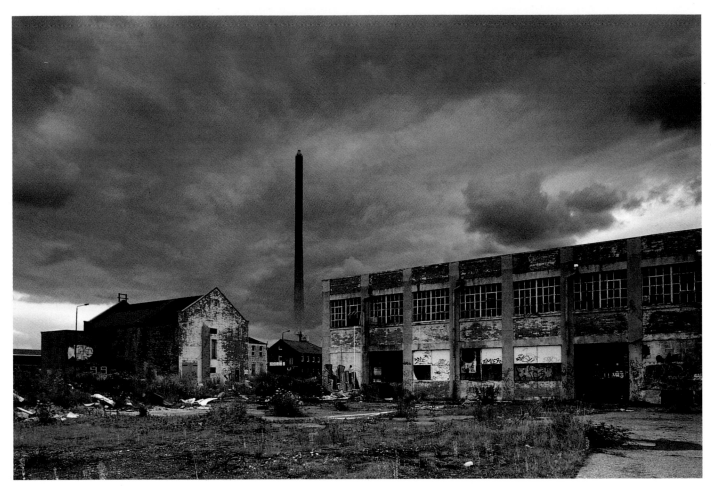

Composition

Jerome Whittingham used a 24mm perspective control lens on a 35mm SLR camera to shoot this derelict factory near his home in Hull. Also known as 'tilt and shift' lenses, perspective control optics are available for a number of 35mm – and medium format – camera ranges. The model Whittingham used is manual focus and rotates on its axis. It can be shifted off centre by as much as 11mm in any direction, horizontal and vertical. This allows the photographer to keep the film back parallel to the subject plane, which means that the verticals stay parallel too.

Technique

The camera must be kept absolutely level for a perspective control lens to work, so Whittingham set up his camera on a tripod and aligned it using a hotshoe-mounted spirit-level. When 'shift' is applied, the image darkens and focusing becomes difficult, so he took a through-the-lens exposure reading first, setting the aperture to f/11, and focused for maximum depth of field. He then carefully tilted the lens until the image appeared as he wanted it in the viewfinder, with the verticals properly aligned.

Lighting

The camera was loaded with Agfa Scala black-and-white transparency film, a contrasty emulsion which, with the right subject, can create very atmospheric pictures (it is processed by specialist labs or can be bought process-paid). Whittingham used it at its nominal rating of ISO 200, although it can be pulled to ISO 100 or pushed to ISO 1600 if required. Two filters – an orange and a graduated neutral density – helped to add drama, increasing contrast and darkening the sky.

technical details

Canon EOS 35mm SLR with a 24mm perspective control lens. Film was Agfa Scala, used with two filters, an orange and a graduated neutral density.

Tip

Commercial photographers use large
format cameras for two main
reasons: image quality and the
adjustable camera front, which is
used to get rid of converging
verticals. A perspective control – or
tilt and shift – lens gives the 35mm
user a similar degree of 'rising
front'. If you don't mind losing a
little detail in the image, the 35mm
format offers a number of
advantages. The equipment is much
smaller and lighter; the image can
be assessed through the lens, right
side up rather than laterally
reversed. The camera retains its
automatic functions, and filters are
more easily aligned. Finally, the
costs of film and processing are
significantly lower.

Once you've got the big picture,
home in on the details. Jerome
Whittingham took this image at the
same industrial location, but this
time simply used a standard 50mm
lens and Agfa Scala film without any
filters. He shot handheld, and tilted
the camera at an angle to create a
diagonal composition.

technical details

Canon EOS 35mm SLR with a 50mm
lens and Agfa Scala black-and-white
transparency film.

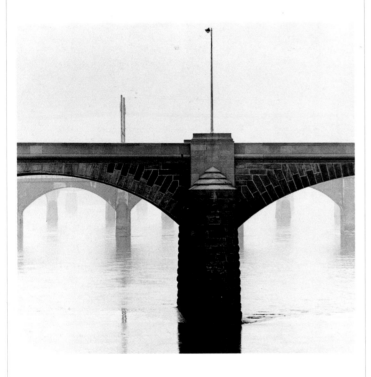

Objective

David Plowden photographed the Market Street Bridge over the Susquehanna River in Harrisburg, Pennsylvania as part of a book project on the history of bridge building in North America. He was faced with a race against time, as many significant examples were disappearing. He spent six years on the project, criss-crossing the US and tracking down obscure structures in forgotten rural corners.

Composition

The Susquehanna River is wide, shallow and unnavigable and has many long, short-span bridges like these. Plowden took the picture on an Easter morning when it was raining and the light was soft and diffuse. He used a Hasselblad camera with a telephoto lens and cropped in close on the span in the foreground, allowing the others behind it to fade gently into the mist.

technical details

Hasselblad camera with a 250mm lens. Film was Kodak Pan-X.

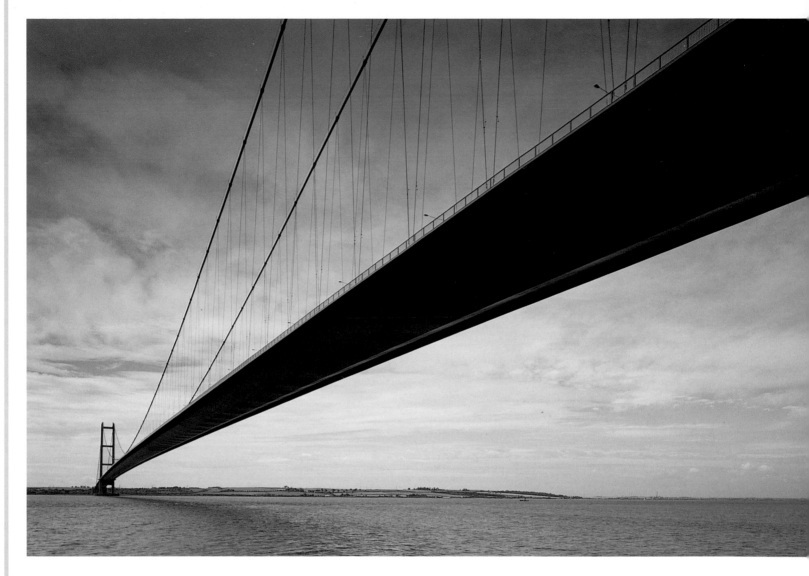

When photographing the Humber Bridge in north-east England, Jerome Whittingham used neutral density and tobacco filters to darken and colour the sky and framed boldly so that the structure cut the picture frame diagonally in two. He used a 24mm perspective control lens on his 35mm SLR to keep the verticals correctly aligned. To ensure the camera was level, he set it up on a tripod and used a hotshoe-mounted spirit-level to adjust it.

technical details
Canon EOS 35mm SLR with a 24mm perspective control lens. Film was Fuji Velvia, used with tobacco and graduated neutral density filters.

Composition

The Casa de Vila Verde winery is in Lousada, a production centre for Portugal's famous vinho verde. Carlos Cezanne photographed the balcony of the house as part of an assignment for an interior decoration magazine. He was looking for unusual angles and details that would show different aspects of the building, with the idea of building up a complete picture. For inspiration, he regularly studies the work of other photographers: he is an avid consumer of style books and interior decoration magazines, from which he frequently picks up ideas for his own work.

Lighting

He shot in available daylight, using slow transparency film with a 6x6cm medium format camera. The illuminated lamp in the top left-hand corner of the frame added interest and lifted the shadows in the dark ceiling area. Cezanne always brackets his exposures, taking five identical shots of the same subject, but on two of them setting the exposure below the recommended meter reading and on two of them above. As well as providing an insurance policy against accidents, this gives him and his editorial clients a choice when they come to select which shot will be used in the magazine. "You never can tell," he says, "sometimes the darker transparency is better."

technical details

Rolleiflex 6008 camera with an 80mm lens. Film was Kodak Ektachrome 100, used in available daylight with an exposure of around 1/2sec at f/16.

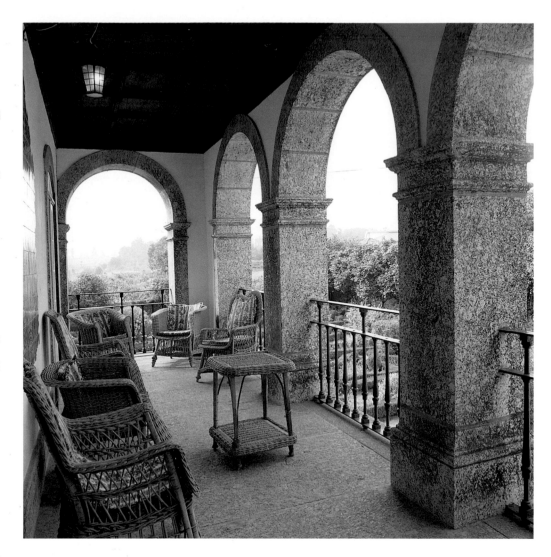

"You never can tell – sometimes the darker transparency is better."

Carlos Cezanne

This was an establishing shot of the main façade of the house. The autumn morning was overcast, with soft and even lighting. Cezanne moved well back and composed the shot so that the leaves of the chestnut tree were visible in the top portion of the frame, filling in a rather washed-out area of sky and creating a natural frame for the building.

technical details
Rolleiflex 6008 camera with a 50mm lens. Film was Kodak Ektachrome 100, used in available daylight with an exposure of around 1/15sec at f/11.

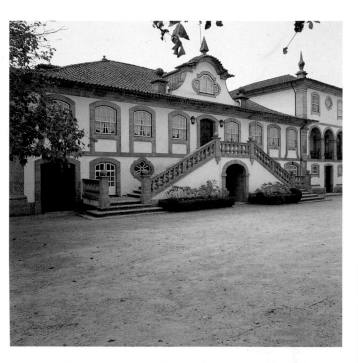

This interior shot showed one of the establishment's outhouses, used for wine bottling. Cezanne used a mixture of natural and artificial light, with the overhead bulbs switched on and sunlight streaming in through the open door. He made maximum use of this natural light by placing three reflectors strategically around the room to throw light into the darker corners. One was just next to the camera, where a second doorway provided an additional source of light. With a wide angle lens stopped down to f/16, the exposure time was a couple of seconds.

technical details
Rolleiflex 6008 camera with a 50mm lens. Film was Kodak Ektachrome 100, with an exposure of a couple of seconds at f/16. Available daylight augmented by reflectors.

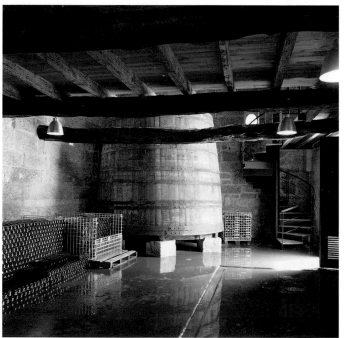

Composition

Angelo Hornak took this shot of the Senso-ji temple in Asakusa, Tokyo as a stock shot for his own picture library. He used one of his favourite cameras, a 6x7cm Corfield, which is designed specifically for architectural photography. "It has a rising front with a lot of movement — 1.5cm — and, almost uniquely, the viewfinder is connected to the front, which means you can adjust the verticals very quickly. Normally with large formats you have to get under a cloth and fiddle around with a ground glass screen," explains Hornak. "It also has a very high-quality lens, as good as you can get." The Corfield has a fixed 47mm lens, takes a standard 6x7cm Mamiya film back and, at a pinch, can be used handheld.

Technique

There are two types of shutter available for this camera, and here Hornak was using the self-cocking Prontor-press type, which cocks and fires the shutter all in one movement when the cable release is pressed. This is especially useful for multiple flash exposures indoors, where re-cocking the shutter by hand is likely to jog the camera. For this exterior shot, the lens was set to infinity. There was sufficient depth of field to ensure that virtually everything was sharp, from front to back.

Lighting

"I was really keen to let the lanterns light the shot," says Hornak. He secured the camera firmly on a tripod and lined up the avenue of lanterns with the famous Thunder Gate archway at its apex, adjusting the rising front to ensure that the verticals were correctly aligned. Using relatively high-speed ISO 400 transparency film gave him an exposure of 8 seconds with an aperture of f/11.

technical details

Corfield WA67 camera with a 47mm Schneider Super Angulon lens. Film was Fujichrome Provia 400, with an exposure of 8 seconds at f/11.

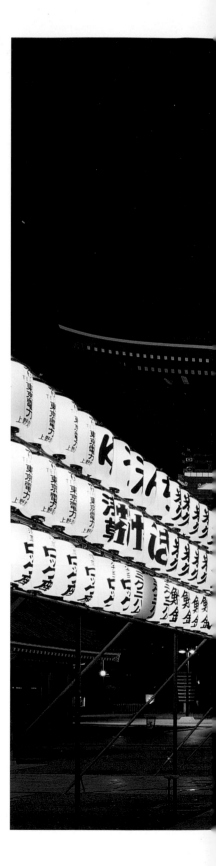

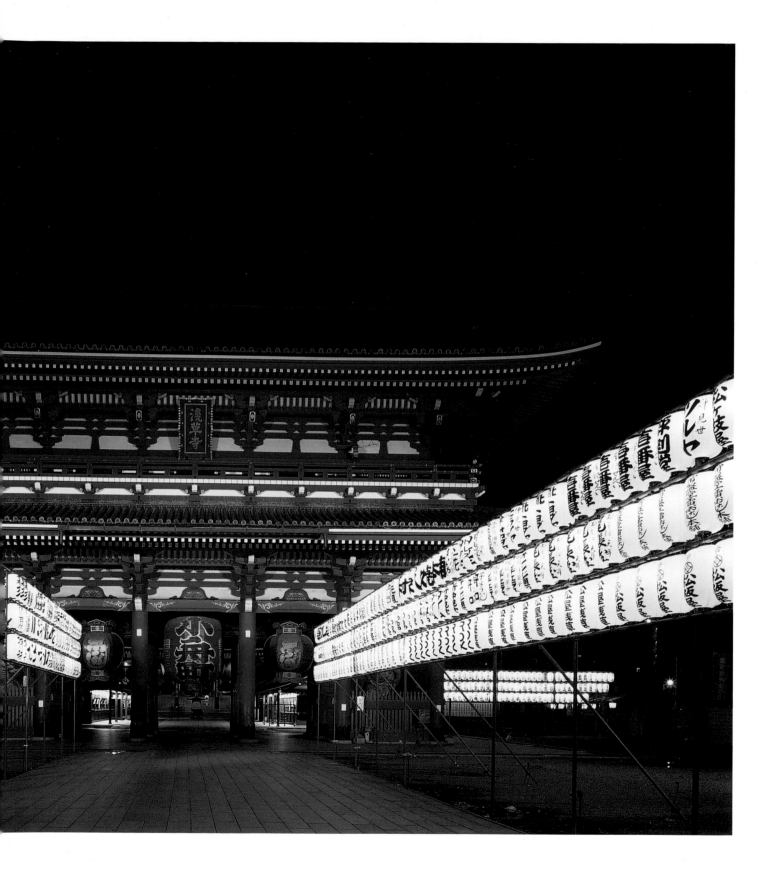

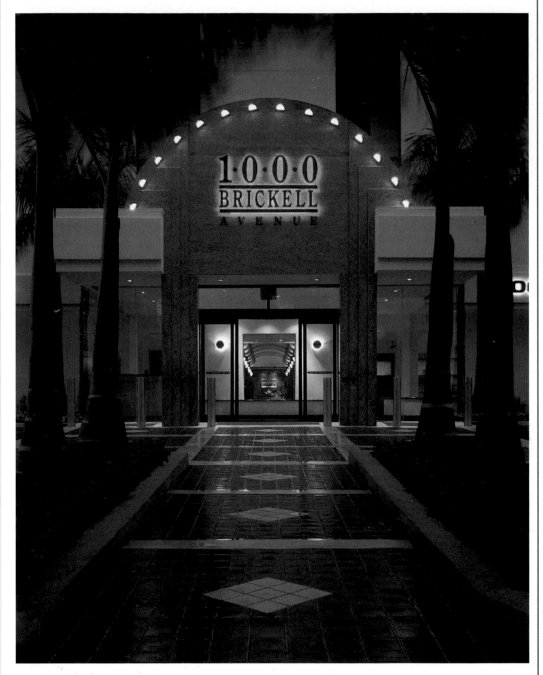

Composition

The owners of this office building wanted it photographed for the cover of a rental brochure. Mark Surloff chose to shoot at dusk, a time of day that has its own special atmosphere. "It's a magical time of the day, but it usually only lasts for 20 minutes after sunset," he says. He positioned himself at the end of the pathway, using the arch formed by the palm trees to provide a frame and the concrete kerbs of the flower beds to lead the eye towards the illuminated lobby. A wide angle lens and a low camera angle helped to add impact.

Lighting

Surloff habitually uses a colour temperature meter to take a reading of a scene, and here it indicated that he needed a pale blue 82A filter to balance up the colours. The exposure time was a lengthy 22 seconds and consequently the light evening breeze caused the palm fronds to blur slightly. Although here he was using daylight-balanced transparency film, sometimes at dusk Surloff shoots with tungsten film balanced for indoor lighting. "It gives an unreal but a quite beautiful and dramatic effect," he explains.

Technique

Small details can make or break a picture, and most subjects benefit from a little tidying up. Surloff carries a ladder as part of his kit and here it proved invaluable, as a blown lightbulb on the façade had to be replaced. He also sluiced down the pathway with a hosepipe; once wet, the paving reflected the lights of the building and helped lift the foreground. To ensure that the details – and the lighting – are right, Surloff invariably takes a number of Polaroid test shots. "Try to determine the quantity of film and Polaroid materials you need for any assignment – then double it," he advises.

technical details

Sinar Standard 5x4in camera with wide angle bellows and a 120mm Schneider Angulon lens. Film was Kodak Ektachrome 100, used with a pale blue filter, and the exposure was 22 seconds at f/32.

"Try to determine the quantity of film and Polaroid materials you need for any assignment – then double it."

Mark Surloff

The graphic shape of this movie theatre called for a bold composition, and the dramatic evening sky gave Mark Surloff a perfect background. Using a tripod-mounted 35mm camera, he got in relatively close and shot from a low angle, outlining the building against the clouds and using a pale yellow filter to enhance the red tones of the sunset. Opening up the lens to f/11 gave him a shutter speed of two seconds, which was just fast enough to avoid the people in the lobby appearing blurred.

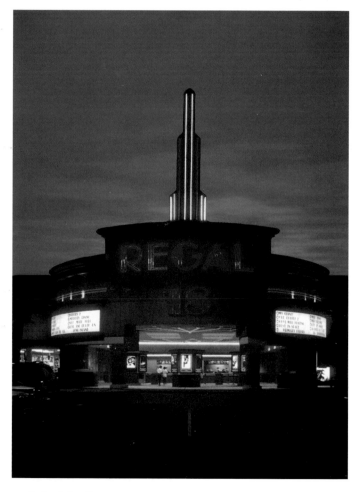

technical details
Nikon FE2 SLR camera with a 35mm lens. Film was Kodak Ektachrome 100, with an 81B filter and an exposure of two seconds at f/11.

"For exterior shoots, arrive early and leave late – and carry a leaf trimmer."

Mark Surloff

Mark Surloff made another early Sunday morning start when he photographed this apartment block, choosing the time of the week when traffic would be at its lightest. He arrived at dawn, but waited three hours before the shadows cast by the rising sun gave the best effect. A polarising filter rotated to its maximum setting saturated the colours and deepened the blue of the sky. Surloff could do little at the time about the numerous unsightly power lines strung across the front of the building, but later he scanned the image into a computer and removed them digitally, using Adobe Photoshop software.

technical details
Sinar Standard 5x4in camera with wide angle bellows and a 90mm Schneider Super Angulon lens. Film was Kodak Ektachrome 100, used with a polarising filter, and the exposure was 1/15sec at f/32.

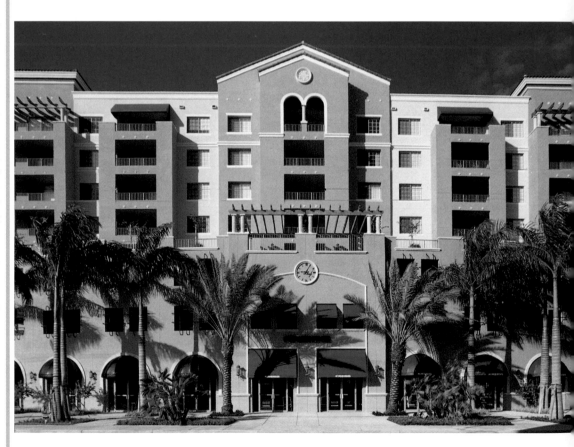

Composition

Shooting for a construction company brochure, Mark Surloff arrived on location early on a Sunday morning when the light was good – and when there was little traffic about to spoil the shot. Using 35mm equipment, he chose a low camera angle and used the palm trees to frame the building. However, his view was partially obscured by the foliage in the foreground, so he used a leaf trimmer to cut it back to the shape he wanted.

Lighting

The lighting for this shot was relatively straightforward – just early morning daylight, with a polarising filter to deepen the blue of the sky. "For exterior shoots," says Surloff, "you need to arrive on location before sunrise and leave after sunset for the most dramatic and telling light."

technical details

Nikon FE2 SLR camera and a 35mm lens. Film was Kodak Ektachrome 100, used with a polarising filter, and the exposure was 1/15sec at f/32.

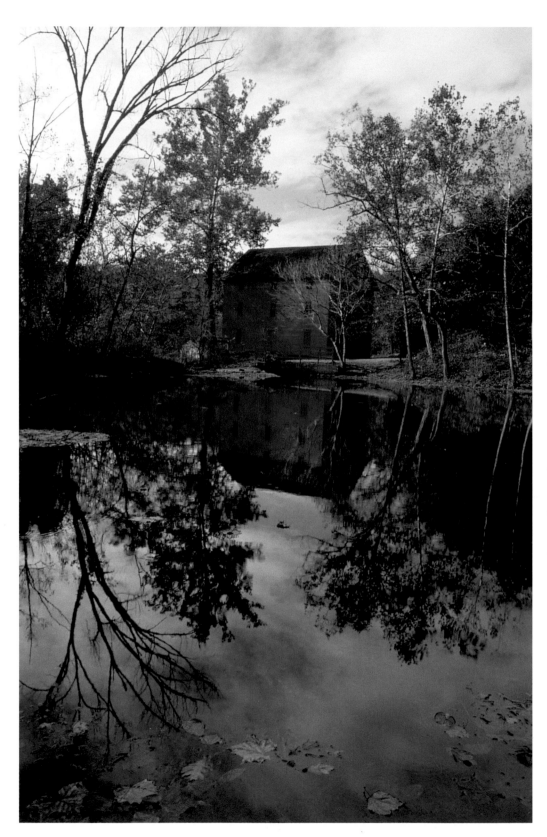

Steve Warble takes pictures while backpacking and walking. Travelling light, he carries just a 35mm SLR camera fitted with a wide angle lens, together with spare film and a few filters. Most of his outdoor pictures are handheld: although he normally carries a lightweight tripod, he uses it for around only a quarter of his pictures.

This mill – Alley Mill – sits besides one of the large springs that feed the Ozark Riverways in Missouri. Using a 28mm wide angle, Warble framed so that the reflection of the mill and the trees created a beautifully symmetrical composition, with the building blending harmoniously into the landscape.

technical details
Pentax Spotmatic II camera with a 28mm lens and Kodachrome 64 transparency film. Handheld using available light.

Lighting

Gregoire shot this old wooden mansion as part of a project to document the Connecticut coastline. The bright sunlight reflected by the white paintwork accentuated the lines and textures of the building. To heighten the contrast and darken the sky, he used a number 25 red filter. This type of filter makes black and white images more contrasty by blocking the blue end of the spectrum.

Technique

It was the Fourth of July and the Stars and Stripes flying from the porch gave the picture a patriotic flavour, but the flag could only be seen properly when puffed out by the wind. The red filter cut the maximum shutter speed to half a second, which meant that if the flag was moving even slightly it would record as a blur. For that reason Gregoire had to time his shot carefully, firing the shutter when the flag was fully extended but momentarily still.

technical details

Omega monorail 5x4in view camera with a Schneider 150mm lens. Kodak Tmax 100 sheet film with a number 25 red filter, and an exposure of 1/2sec.

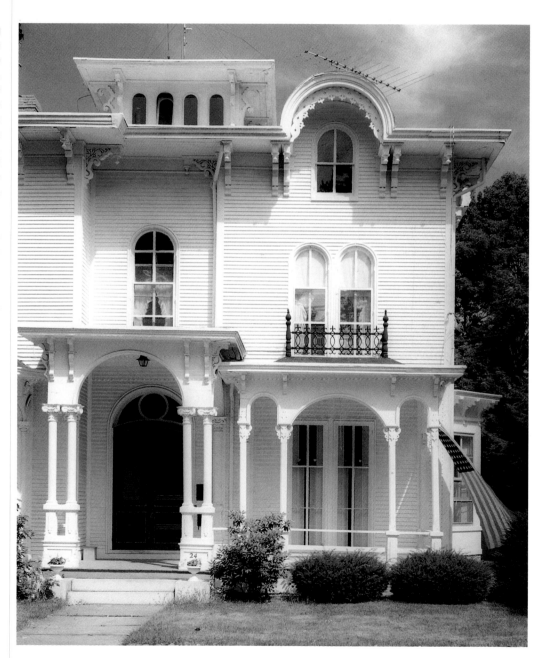

Composition

Commissioned by an architectural magazine to photograph this stunning private residence, Björg chose to highlight the geometry of the building. She selected a 50mm wide angle lens and framed so that the lines of the house converged on the illuminated interior behind the transparent curtain wall - although the room in the right foreground, located near an intersection of thirds, provided an alternative focus of interest. She emphasised the horizontal nature of the structure by making a print from the 120 transparency and cropping it top and bottom, so that the format became virtually panoramic.

Lighting

Shooting at dusk meant that the deepening blue of the sky created a strong contrast with the illuminated interior of the building, while the exterior walls appeared in semi-silhouette. Björg used a daylight-balanced film, which recorded the pockets of artificial lighting with a warm yellow cast. The foliage in the foreground, however - blurred slightly during the long exposure by wind movement- registered with a cold blue tone.

technical details

Mamiya RB67 camera with a 50mm lens and Fujichrome Provia transparency film.

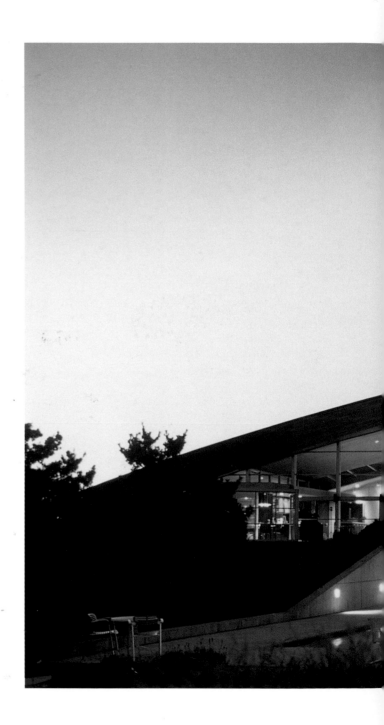

"I look to create images that are simple but vibrant, with creative lighting as a hallmark." Björg

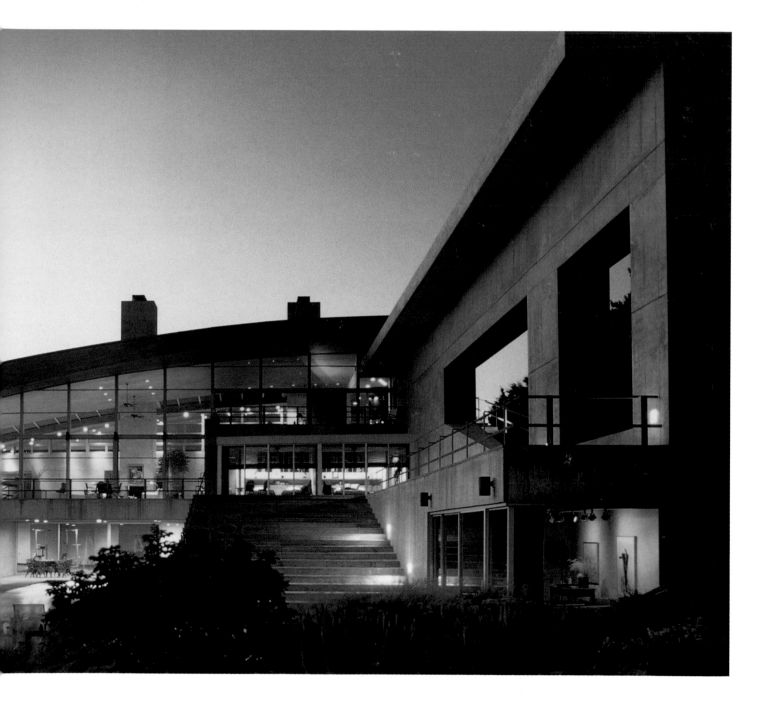

interiors

Interiors range from the ornate to the austere, the grand public space to the intimate and domestic. Whatever the subject, mood can be altered dramatically by the choice of lighting – ambient, artificial or a mixture of the two. Sometimes natural daylight, imaginatively used, offers the most effective option.

"Extra light sources such as flash make interiors look unreal; besides, they are time-consuming and send the budget soaring." Koen van Damme

Composition

For an architect, there is no more personal a statement than the house he designs for his own use. When Koen van Damme was commissioned to photograph the dwelling of Belgian architect Frederic Leers, seen opposite, he wanted to show the way the interior and exterior had been designed to blend seamlessly together. He also wanted to capture the way that light and shadow had been used to add an extra dimension to the building.

Lighting

Van Damme always takes his photographs using available light. This can be natural daylight or artificial light, or a combination of the two. "Extra light sources such as flash bulbs make interiors look unreal – that's why I prefer available light," he explains. "Besides, the use of extra light sources is time-consuming and sends the budget soaring." For this shot he used daylight-balanced transparency film, selecting a type of Ektachrome that has a slightly higher colour saturation and warmer tones than normal.

technical details

Hasselblad FlexBody view camera with a 60mm lens. Film was Kodak Ektachrome 100 SW, used in available daylight.

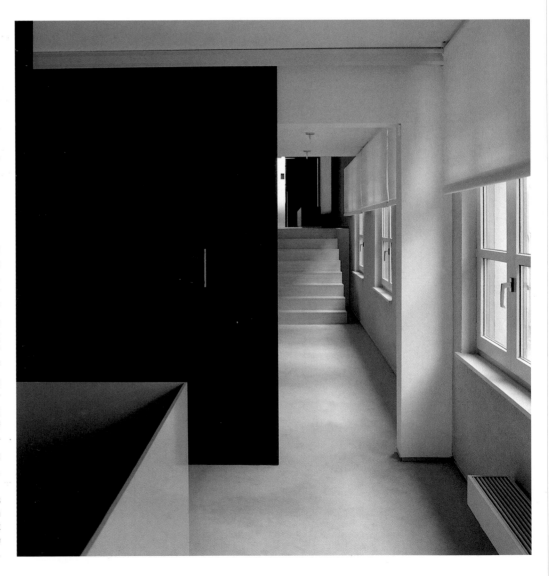

Koen van Damme was commissioned
by the architect to photograph the
newly completed bank building, seen
opposite, and he used available
window light as his sole source of
illumination. The daylight made the
colours appear natural, though van
Damme saturated them slightly by
using a warm-toned transparency film.

technical details
Linhof Technikardan 6x7cm camera with a
90mm lens. Film was Kodak Ektachrome 100
SW, used in available daylight.

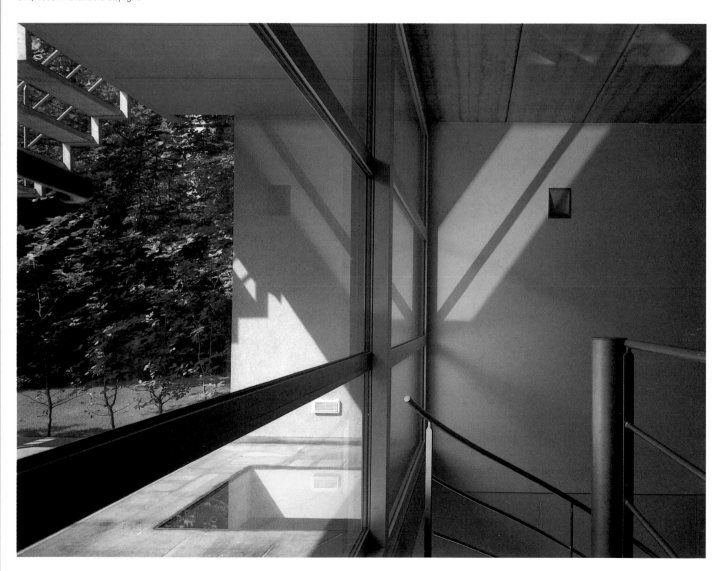

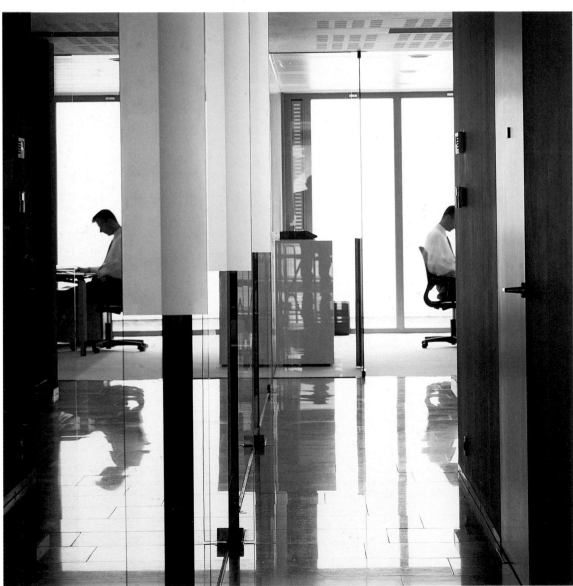

Preparation
Preparation is essential for any assignment: especially when the work has been commissioned and time – and the budget – may be tight. "Discuss the assignment in advance with the architect," advises Koen van Damme. "Make sure you know what he considers important and ensure that you capture this in your pictures."

Composition
In this case van Damme had been commissioned to photograph the Bacob bank building in Deurne, Holland. The building was light and airy, and the architect wanted pictures that conveyed its feeling of transparency. The client also wanted a human element, so van Damme used the many reflective surfaces to underline the presence of staff and customers going about their business. For this shot, lit with available daylight, he used colour transparency film, although the building's minimalist design and décor meant that the result was virtually monochrome.

technical details
Hasselblad FlexBody view camera with a 60mm lens. Film was Kodak Ektachrome 100 SW, used in available daylight.

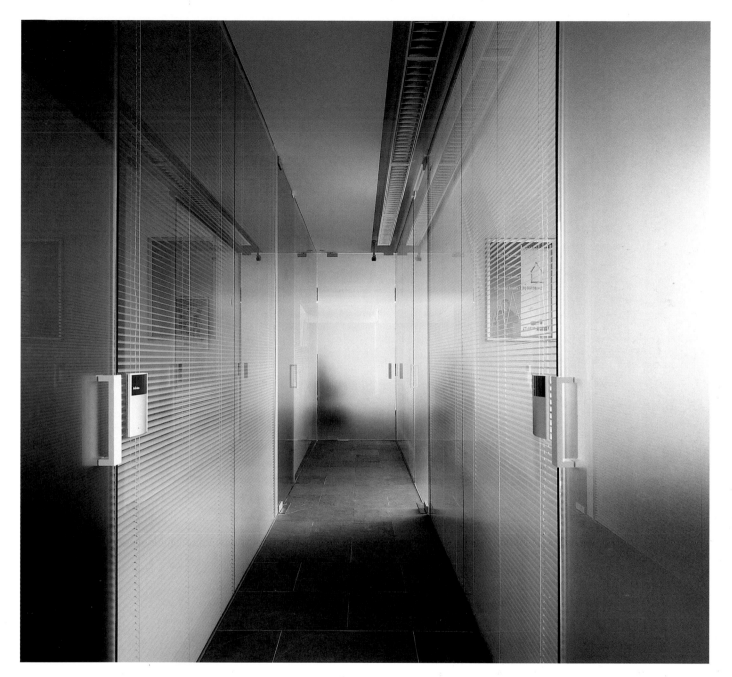

The austere lines of this bank building in Geel, Belgium were accentuated by the cool, blue light filtering into the corridor. Koen van Damme used a wide angle lens for this neatly symmetrical shot, for which available daylight provided the sole illumination.

technical details
Hasselblad 903SWC camera with a 39mm lens. Film was Kodak Ektachrome 100 SW.

Composition

Sometimes you have to work quickly. "The security guards at the Tokyo International Forum didn't really want me taking pictures with a tripod so I had to set up quickly before I was moved on," says Angelo Hornak. "That's quite normal – just a hazard of the job." He used a specialist Corfield architectural camera, which has a rising front connected directly to the viewfinder. "You can see the effect of corrections through the viewfinder as you're making them," says Hornak, "so it's a quick and easy job to get the composition right."

Technique

It's normal to use fast films when shooting interiors but on this occasion Hornak had his favourite Fuji RDPII loaded, and it proved perfectly adequate for the job in hand. "It's slower but it has very fine grain," he says. "It's also very versatile and holds its reciprocity characteristics down to very low levels – you can use it at 1/60sec or at 20 seconds, or with flash, and still get consistent colour results." In this case the exposure required was four seconds, so a tripod was essential.

Lighting

There was some daylight in this interior, but most of the lighting was artificial. "Strictly speaking I should have used tungsten film, which would have given a more blue-green result overall," says Hornak. On tungsten film daylight registers as blue, which is noticeable if there are windows in the shot. It's relatively simple to correct daylight for tungsten film by using an 85B amber filter, but problems arise when the light sources are mixed. "I would use tungsten if I knew there was no daylight in the interior, and also for outdoor floodlighting at night," says Hornak.

Tip

The seated people have registered clearly in this interior shot but if you look closely you can see 'ghost' images in the concourse area where others have walked through during the long exposure. "That will be someone wearing bright clothes," says Angelo Hornak. "Black clothes don't register in long exposures. I always wear dark clothing myself so if for any reason I have to run into the shot during exposure, I don't show up."

technical details

Corfield WA67 camera with a 47mm Schneider Super Angulon lens. Film was Fujichrome Provia 100, with an exposure of four seconds at f/5.6.

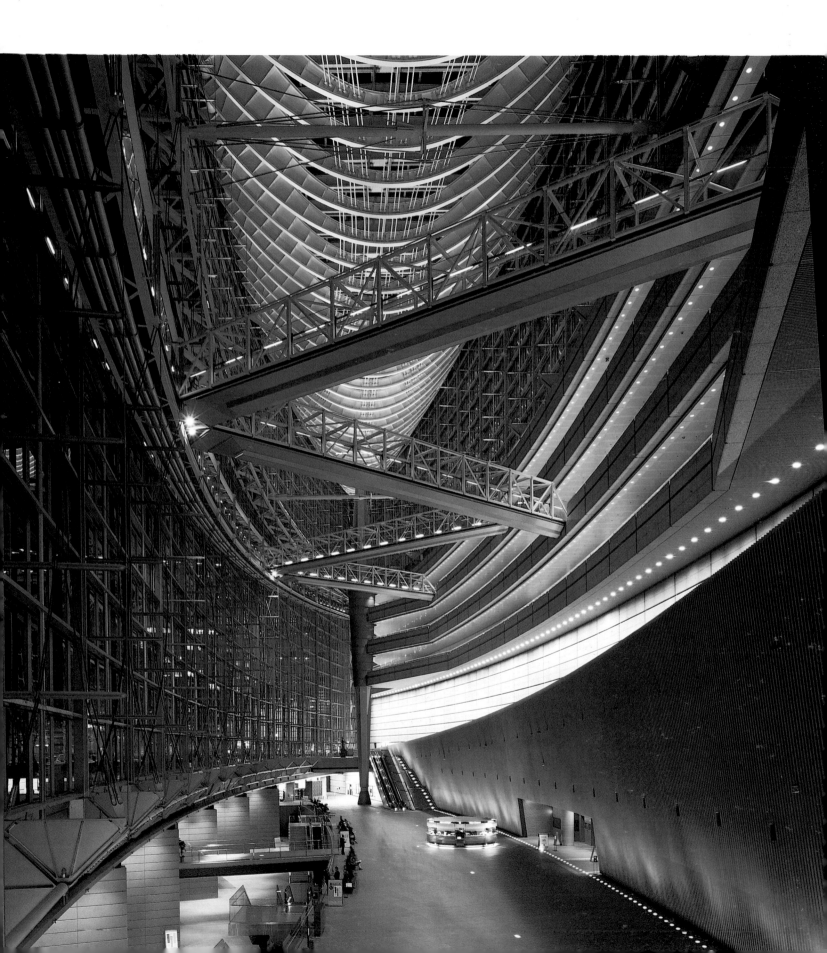

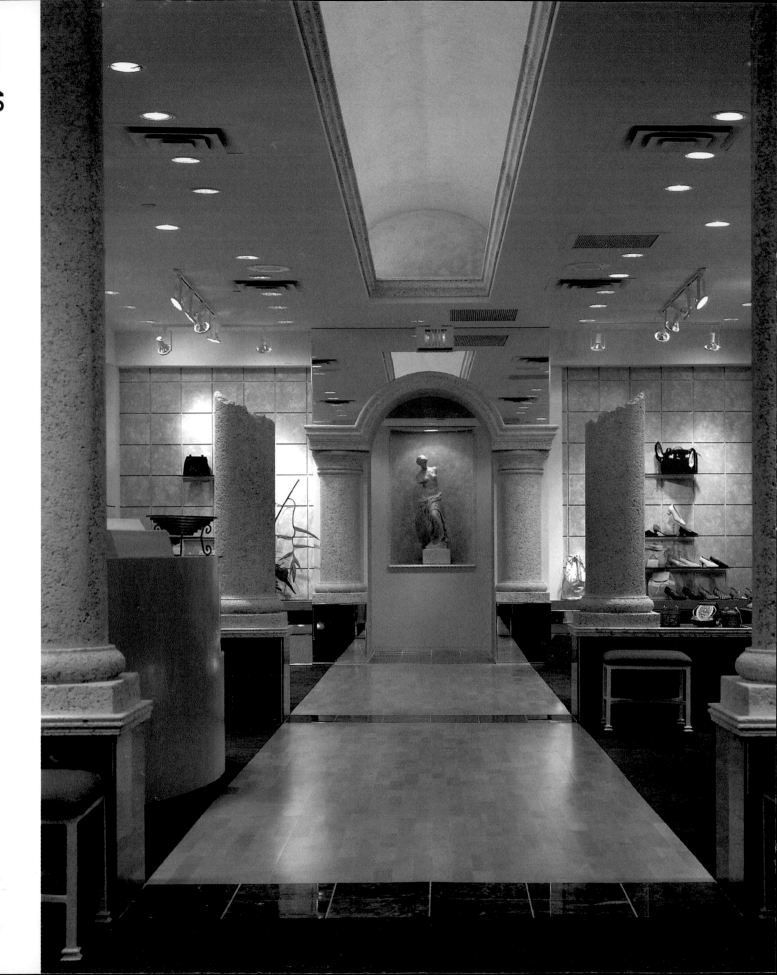

Approach

When work is commissioned, it's essential that both client and photographer are absolutely clear about what the job entails. "Communicate at great length with the client. Discuss any design or architectural details that should be stressed or avoided. Be aware of their goals and desires as well as the intended uses for your photography," counsels Mark Surloff. He shot this upmarket shoe shop on behalf of the architect, who wanted images both for a design competition and for his portfolio.

Composition

Surloff shot from a low camera angle to make the composition more graphic. The columns in the foreground provided a neat framing device, while the wooden floor and the line of columns converging on the statue at the back of the shop created a focal point in the exact centre of the image.

Lighting

A pair of 75-watt Lowell photo floods, used with barndoors to control their light output, helped define the shape of the foreground pillars. Otherwise Surloff used available artificial light. A colour temperature reading indicated the need for an 80D blue filter, but he chose not to correct the green cast created by the fluorescent lighting. However, his Polaroid test shots showed that the overhead striplights were too strong, so he had some of them switched off to reduce brightness in the ceiling area.

technical details

Sinar Standard 5x4in camera with wide angle bellows and a 150mm Schneider Symmar lens. Film was Kodak 64T, used with a blue filter, and the exposure was 10 seconds at f/45.

"Communicate at great length with the client. Be aware of their goals and desires as well as the intended uses for your photography."

Mark Surloff

Composition

Björg draws on her fine art background when photographing interiors. She looks to create images that are simple but vibrant, and creative lighting is a hallmark of her work. This shot of the Idlewild bar in New York was commissioned by an entertainment magazine; her brief was to portray it as a bright and welcoming night-time venue.

Lighting

She used a large format camera loaded with transparency film balanced for artificial lighting. To some extent the picture was illuminated by the bar's own ambient lighting. However, to lift the exposure Björg used two tungsten fill lights. One of these lit the seating area in the background; the other, placed just behind the camera, reflected off the shiny surfaces of the bar counter and the ceiling, ensuring that the foreground was brightly lit.

technical details

Horseman 5x4in camera with a 90mm Schneider Super Angulon lens. Film was Fujichrome 64T, and two tungsten fill lights were used.

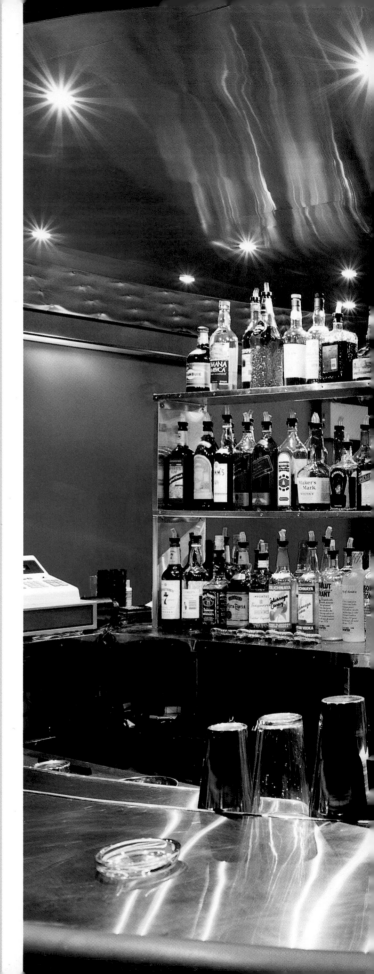

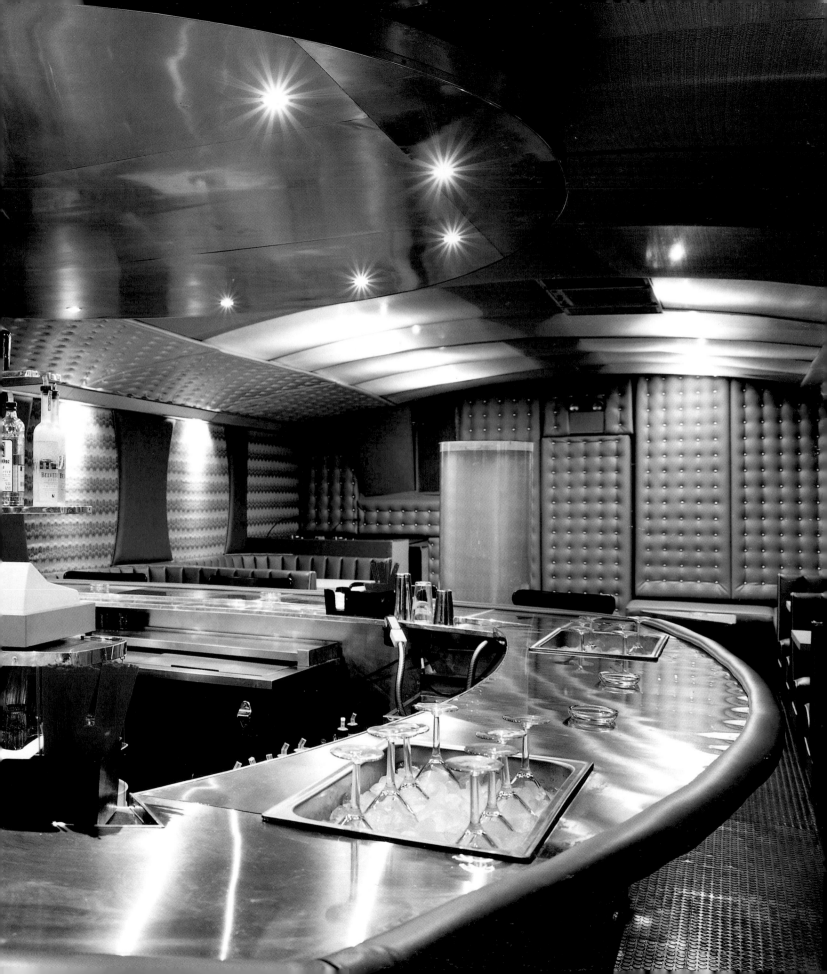

Composition

Michael Reinhard fixed his medium format Hasselblad camera firmly to a tripod and tilted the tripod head to an angle of 90 degrees to take this abstract interior at Canary Wharf in London. A 40mm lens gave him a wide angle of view in which the escalators, the upper floors of the building and the glass roof formed a spiral. Impact was added by the metal pipes converging towards the apex of the glass dome, which he positioned virtually in the centre of the frame.

Lighting

Reinhard prefers to use natural daylight even indoors, and waits patiently for the lighting to change to give him the picture he is looking for. The challenge, he says, is to make even the dullest building "shine". For this shot, there was plenty of light flooding in through the glass ceiling, but Reinhard added depth to the colours by shooting through a pale blue filter.

technical details

Hasselblad 205 camera with a 40mm lens. Film was Fujichrome Provia 100, used with a pale blue filter.

Michael Reinhard's aim when working for his corporate clients is to create "dynamic images that are clear and easy to understand". For this shot, taken at a science park in Ulm, Germany, he used the graphic lines of the corridor and the glass walls to divide the frame into four roughly equal triangular segments. The points of the triangles converged on a small space exactly in the centre of the frame – and just here he placed a pair of human figures to act as a focal point.

technical details
Hasselblad 205 camera with a 40mm lens and Fujichrome Provia 100 film.

Composition

"How the hell am I going to shoot that?" is the first question Michael Conroy asks himself when presented with a tricky architectural subject. Awkward locations, obstructive traffic, intrusive signage, unpredictable weather, mixed lighting, unhelpful tenants, nosy bystanders, eccentric architects and tiny budgets are among the challenges he has to face on a day-to-day-basis. So why do it? "For me it's a love of strong lines, vivid colours, modern curves and classic form," he explains. "To have the opportunity to capture on film some of the unique shapes and forms of a building and to provide the client with a record of the ideas they embody."

Lighting

Conroy was commissioned by the architects to photograph the Megazone games area at the Princess Margaret Children's Hospital in Perth, Western Australia. He wanted to show the room in its full glory, recording good, solid colours while keeping detail in the furnishings. The area was well lit but Conroy decided to wait until after dark as, during the day, the sunlight flooding in through the windows was just too strong. He augmented the ambient light with three small Bowens monolights: one aimed into the room through the windows on the left, one placed behind the blue wall on the right and the third just to the right of the camera. With ISO 160 transparency film this gave him an exposure of 30 seconds at f/16.

technical details

Hasselblad 503 camera with a 40mm Distagon lens. Film was Kodak Ektachrome 100 Plus (EPP), with an exposure of 30 seconds at f/16.

"How the hell am I
going to shoot that?"
Michael Conroy

"I use available light only as I want to respect the lighting effect created by the architect."

David Arraez

Lighting

David Arraez sometimes uses a reflector when photographing interiors, but he never employs artificial lighting. "I use available light only as I want to respect the lighting effect created by the architect," he explains. For this shot, commissioned by architect Eric Pace and destined for magazine publication, Arraez was given free rein to interpret the subtle interplay of light and shade that characterised the interior. The strong sunlight streaming into the room was split into narrow bands by the grid of beams and partitions, while the wooden materials helped to create a feeling of warmth. He balanced the composition by positioning the wooden chair on an intersection of thirds.

Technique

Arraez used a 50mm lens on a medium format camera, and stopped the aperture right down to f/22 to gain maximum depth of field. He also bracketed the shot to ensure an accurate exposure. His normal technique is to make one exposure at the setting recommended by the meter, then further exposures at half a stop under, half a stop over and a full stop over that reading. For this shot, he was working with shutter speeds in the region of half or a quarter of a second.

technical details
Hasselblad camera with a 50mm lens and a tripod. Film was Fujichrome 100 RDP III, with an exposure of around 1/2sec at f/22.

technical details
Hasselblad camera with a 50mm lens and a tripod. Film was Fujichrome 100 RDP III, with an exposure of around 1/2sec at f/22.

This shot was taken as part of the same assignment and again David Arraez bracketed his exposures to ensure a good result in tricky lighting conditions. Here he picked out a corner of the interior to create a semi-abstract composition. "I tend to avoid general or panoramic shots as I like the viewer to discover the building as though they were walking around it and poking their head round corners," he says. This approach gives him the added advantage of being able to cut out any backgrounds that are messy or just plain dull.

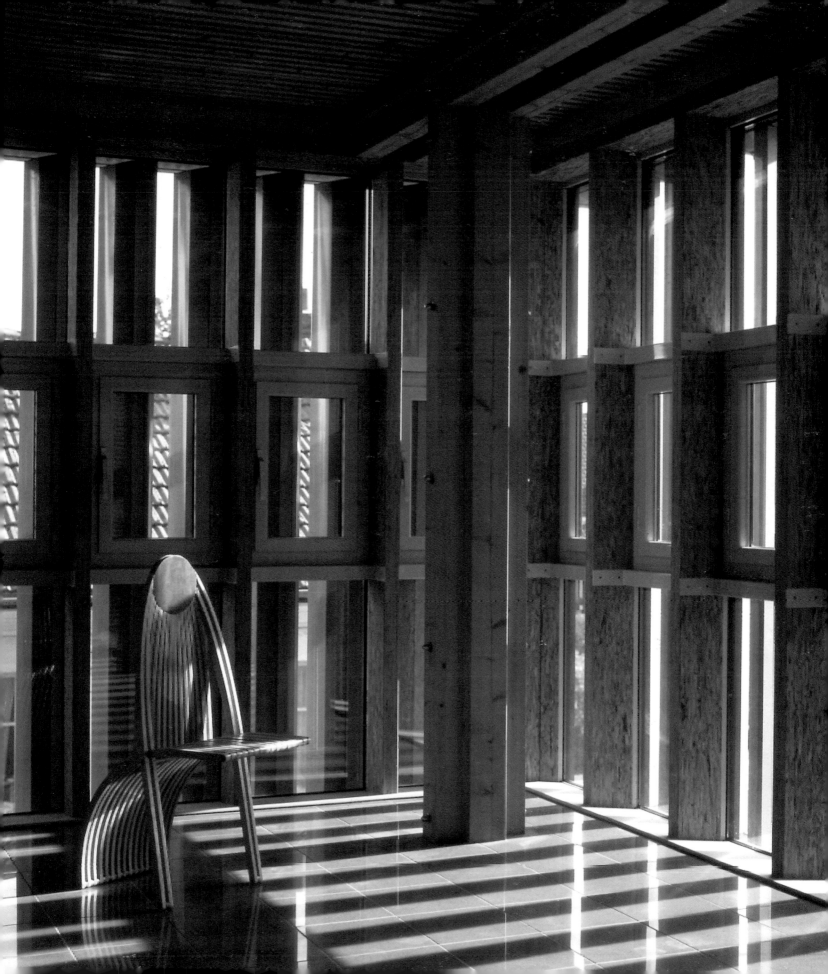

Composition

If you want to photograph popular sites without crowds of tourists spoiling your view, get there early – or go at lunchtime. "I always try to exclude people from my pictures if I can," says Angelo Hornak, "and it's amazing how quickly places empty out at about 1pm." For this shot of the famous chapel at King's College, Cambridge, he used a 5x4in Linhof camera and framed off-centre to create a better sense of balance. "If you stand in the middle of the aisle you get a tunnel effect between the rows of chairs, which is not as appealing," he explains. He used the rising front movement on the Linhof to correct the vertical lines and prevent the illusion of the walls leaning inwards.

Lighting

It was a bright June day and there was plenty of sunlight streaming in through the windows. However, the high levels of contrast meant that detail was lost in the dark wooden panelling of the rood screen. To correct this, Hornak used fill-in flash from a pair of Bowens Mono Traveller flash heads placed behind the camera and a spotlight angled to pick up the screen. For this kind of job he usually carries three heavy studio packs, which can be linked together via photocells. These provide plenty of power for lifting shadow areas.

Technique

To assess any tricky lighting situation, and always when using flash indoors, Hornak shoots a Polaroid. He uses 5x4in sheets of Polapan Pro 100, which is black and white but which has the same contrast characteristics as colour transparency film. "It's not cheap, and you can easily use three sheets before shooting any film, but it's essential for judging how the picture is likely to look," he says.

Tip

Churches and cathedrals look better with the light coming from one side, illuminating stained glass and accentuating shadows, according to Angelo Hornak. Most Christian buildings are aligned west-to-east so, in the northern hemisphere, mid-day is a good time to shoot interiors, when the light is coming from the south. One exception is Coventry Cathedral, which was built at right angles to the old cathedral destroyed in World War II. Mosques in the Near East all point east towards Mecca, which makes early morning the best time of the day for photography. However, for Muslims in Asian countries such as India and Indonesia, Mecca is to the west, so their buildings are aligned the other way around, making evening a better time. How do you work out which way you're facing? "Carry a compass," advises Hornak.

"It's amazing how quickly places empty out at lunchtime."
Angelo Hornak

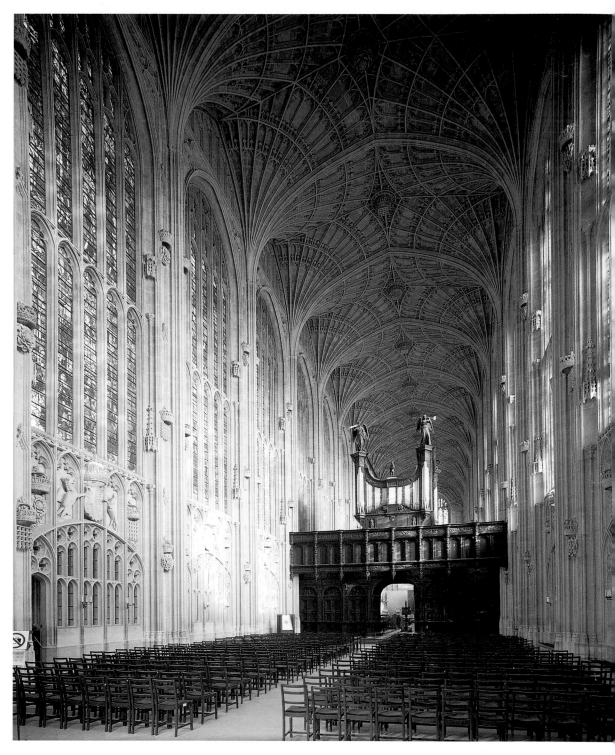

technical details
Linhof 5x4in camera with a 90mm
Super Angulon lens and two Bowens
Mono Traveller flash heads. Film was
Fujichrome Quickload (RDP 100), with
an exposure of one second at f/16.

Composition

The gallery in the eighteenth century Gothic folly of Strawberry Hill in Middlesex is rich in detail. To capture it, Angelo Hornak used a 5x4in Linhof camera with a 75mm lens. With 5x4in, a 'standard' lens is 150mm, which makes 75mm a wide angle. It equates roughly to a 24mm lens in 35mm photography, where the standard lens is 50mm.

Lighting

Technically, this was a very complicated shot. Hornak wanted the effect of natural daylight, but the light falling through the windows illuminated only part of the room. Exposing for the windows made the fan-vaulted ceiling too dark, and exposing for the ceiling meant that the windows burned out. Therefore he had to balance the two using a combination of daylight and flash.

Technique

Hornak set up three flash heads with umbrellas as far behind the camera as space would allow, then went round the room taking a series of ambient light readings with a handheld meter. The overall exposure reading for the scene was 9 seconds at f/16. The three flash heads yielded an aperture of f/8, so he worked out that he would need to make three separate exposures of three seconds apiece to get the right balance of flash and daylight. To judge the effect, he made test exposures with Polaroid's Polapan 100 instant black-and-white film; it took four attempts before he was happy. He used a self-cocking Prontor-press shutter on the camera to avoid any accidental movement between exposures, and had to wait three seconds each time for the flash heads to recycle.

technical details

Linhof 5x4in camera with a 75mm lens. Film was Fujichrome Provia 100, exposed for 9 seconds at f/16, using a mixture of flash and natural daylight.

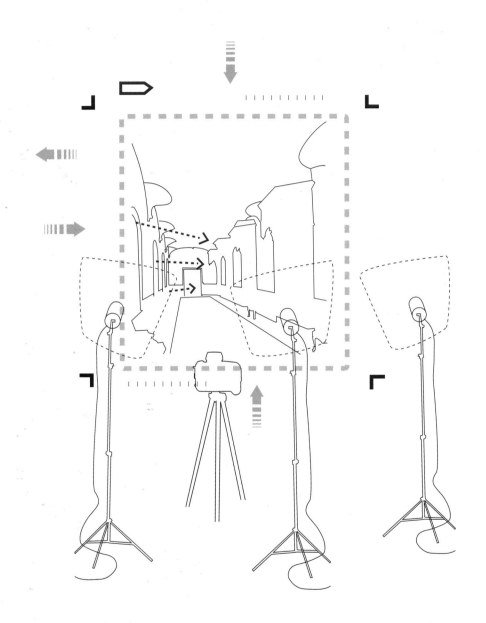

Tip

Permits are sometimes required to photograph inside public buildings, especially museums and galleries, stately homes and churches. The same is true of some archaeological sites. Permits are intended either to restrict the number of professional photographers exploiting the building for commercial gain, or simply to protect the structure and contents from damage. Tripods can scratch tiles or wooden floors, for example, while repeated bursts of flash can accelerate the fading of delicate paintings and fabrics. Check whether a permit is required before setting out. If it's too late for that, ask politely – but respect the rules if you're turned down. Sometimes you can get away with using the minimum of equipment and hoping to be taken for a tourist, but be discreet and don't push the point if challenged. And if this kind of subterfuge leaves you with a troubled conscience, at least put some money in the donation box. Many historic buildings are run on a subsistence budget and rely on public generosity to stay open.

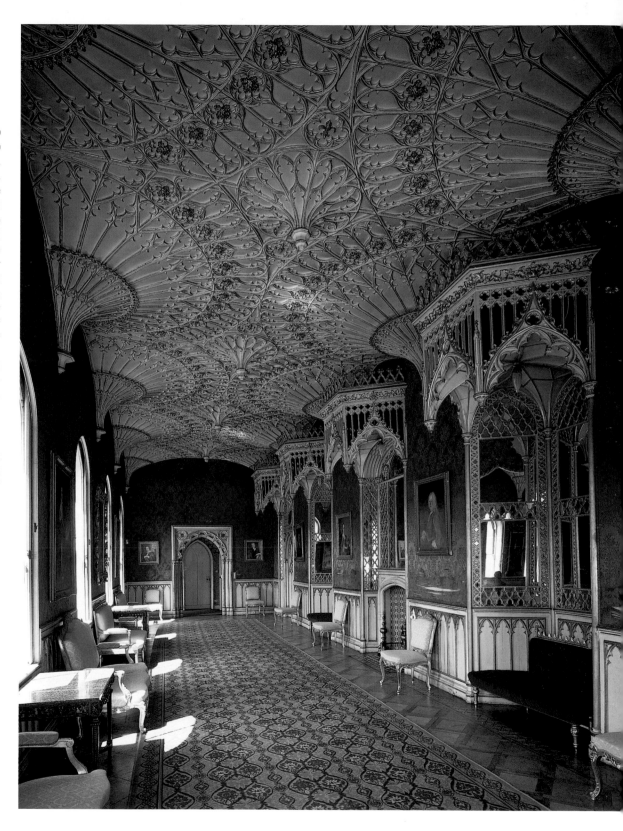

"I never touch or move anything. I see the whole photograph, complete, the way it was at the time."

David Plowden

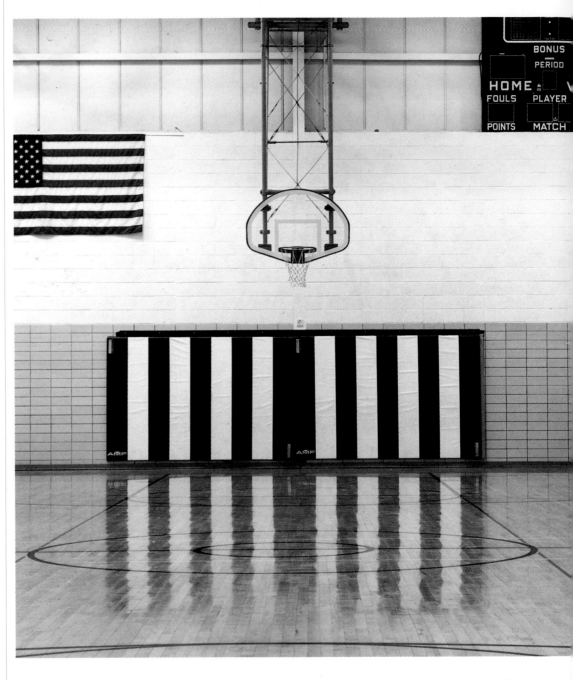

This picture of the Montezuma School gymnasium was part of a book project David Plowden did on Iowa, a state which takes its basketball extremely seriously. He had to get advance permission from the school before being allowed to take any pictures, but technically the shot was quite straightforward. Plowden used a tripod-mounted 6x6cm Hasselblad camera and shot in available light.

technical details

Hasselblad camera with a 60mm lens. Film was Kodak Tri-X Pan Pro, used in available light.

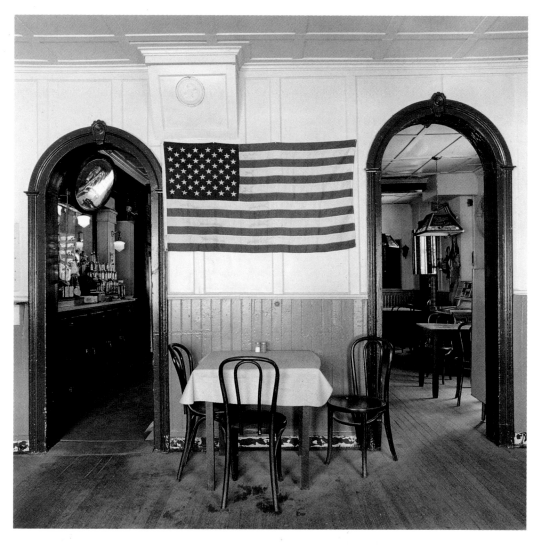

Approach

David Plowden has spent a long and distinguished career documenting the rapidly disappearing domestic architecture and industrial heritage of the United States. Describing himself as "an archaeologist with a camera", his subjects have included small-town shops, family farms, bridges, mills, tugboats and steam trains, all of them threatened by accelerating development. "It has been said about my work that I have spent my career one step ahead of the wrecking ball," he says. "Today I fear I am one step behind it."

Composition

He photographed the Western House in Springville, New York — which had been modernised and embellished with fake Victoriana over the years — as part of a book project about small-town America. The owner wanted to tidy the place up before he photographed it, but Plowden insisted it was left exactly as it was, dust and all. "I never touch or move anything. I see the whole photograph, complete, the way it was at the time," he explains.

Technique

He used a tripod-mounted Hasselblad camera and shot using available light. "Once I see everything is in place, that the light is right, then I fire the shutter," says Plowden. "What I see is then what I print. There are no epiphanies in the darkroom — only the dread that I may make a mistake developing the film."

technical details

Hasselblad camera with a 60mm lens. Film was Kodak Tri-X Pan Pro, used in available light.

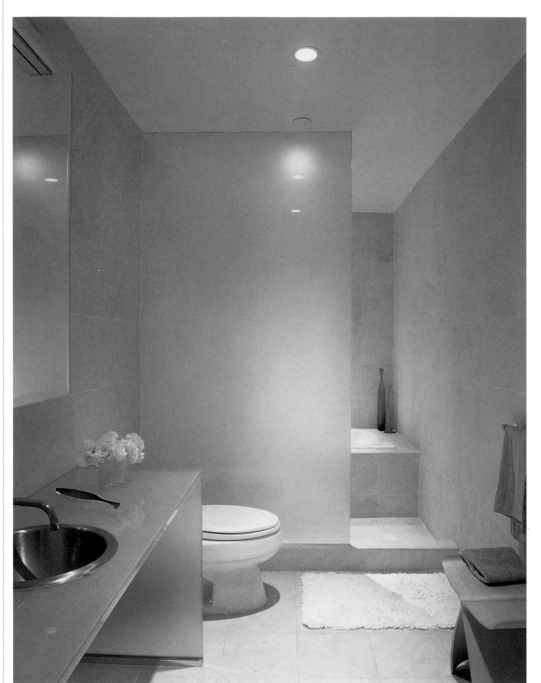

Architect Kar Hwa-Ho commissioned Björg to photograph this sleek and elegant New York City bathroom. She chose medium format equipment with tungsten-balanced transparency film, and lit the space with a combination of available light and a single tungsten fill light. The effect was deliberately soft and diffuse, reflecting the calm and relaxing atmosphere of the room.

technical details

Mamiya RB67 camera with a 50mm lens and Fujichrome 64T transparency film. Shot in available light with one tungsten fill.

Composition

Björg was commissioned by a magazine to photograph the spectacular New York home of architect Rafael Viñoly and she took a series of shots, both inside and out, of this uncompromisingly modern house. For this one, she positioned herself to one side of the entrance lobby and used the sculpture in the left foreground and the steel banister on the right – both positioned roughly on intersections of thirds – as compositional points of reference. The staircase leading off into the distance provided a useful device to draw the eye into the picture, with the far window serving as a point of focus where the stairs met the curved sweep of the ceiling.

Lighting

The interior was flooded with natural daylight, which provided ample lighting and also created some interesting highlights on the monumental concrete pillars. Using a large format camera with fine-grain transparency film for the greatest possible detail, Björg stopped the lens down to f/32 to ensure maximum depth of field. She continued shooting right through the day – an exterior view of the house, taken as night fell, can be found in chapter 1.

technical details

Horseman 5x4in camera with a Schneider 150mm lens. Film was Fujichrome Provia, with an exposure of one second at f/32.

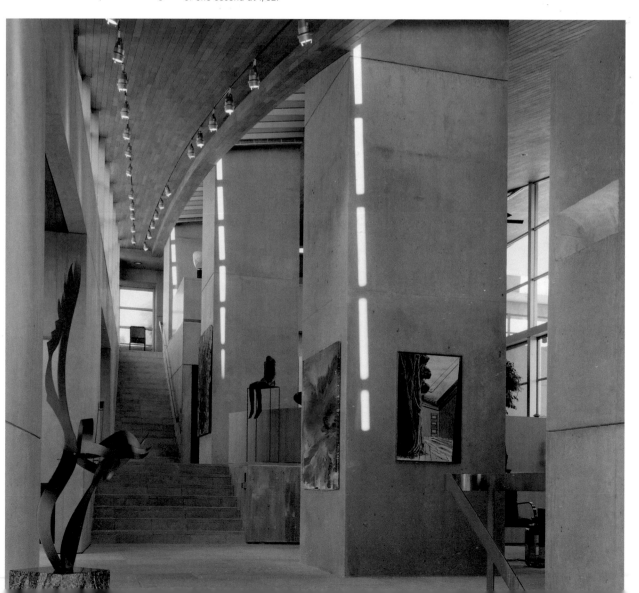

Preparation

"Success lies in the details," says Mark Surloff, which is why he does a 'walkthrough' before shooting any interior. "Walkthroughs are nearly as important as the shoot itself. Try to imagine – in great detail – the best time of day to get there; the best time of day for pictures; film, lens and filter choices; and all the shooting angles," he advises. He often hires a professional interior stylist to ensure that the room he is photographing looks its best. "Working with a stylist allows the photographer to concentrate on photography rather than be distracted by set design details," he says.

Lighting

Surloff shot this desirable residence for an interior design competition. While doing his walkthrough he noticed the light streaming dramatically into the room and fixed this as the time he would photograph it on the day of the shoot. To augment the natural light, he used two 1,500-watt 'super daylight' lamps, one aimed at the upper left-hand side of the painting on the back wall and one at the arm of the couch in the right foreground. He also placed a 5x3ft piece of white card so that light was reflected back onto the nearest of the gold side-tables.

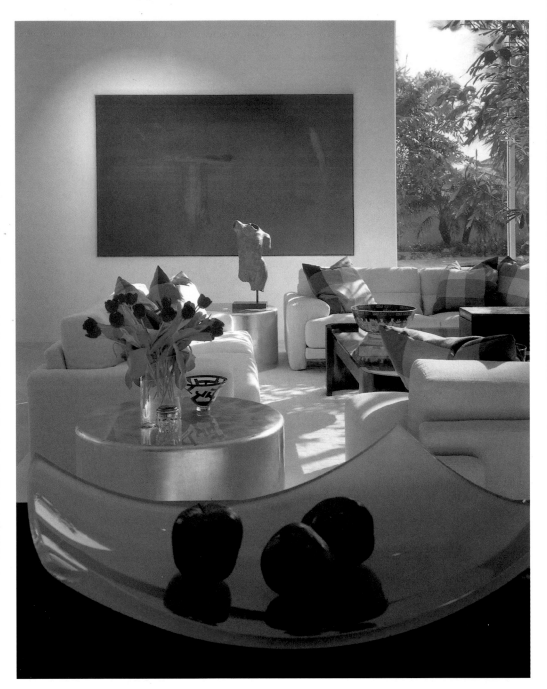

technical details

Sinar Standard 5x4in camera with wide angle bellows and a 210mm Schneider Symmar lens. Film was Kodak Ektachrome 100, used with a pale blue 82B filter and with an exposure of eight seconds at f/45.

> "On a walk through try to imagine the best time of day for pictures, film, lens and filter choices and all the shooting angles."
>
> Mark Surloff

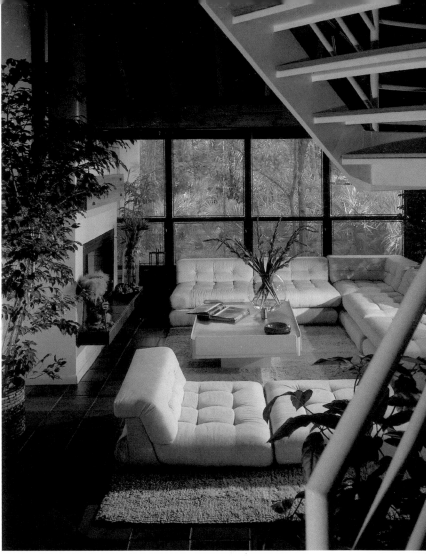

To ensure clean and accurate colour rendition, Mark Surloff always uses a colour temperature meter when working indoors. Here, with Kodak 64T transparency film (which is balanced for artificial light), it indicated the need for a blue 80D filter. The calculation involved a combination of natural and artificial illumination, with four 500-watt lights being used to light the interior. The shot had been commissioned by the architect for an interior design competition and for his portfolio, and the room had to look its absolute best. Surloff hired a professional stylist to take care of details such as the open book and the flowers on the table, which helped to suggest just the right balance between style and comfort.

technical details

Sinar Standard 5x4in camera with wide angle bellows and a 210mm Schneider Symmar lens. Film was Kodak 64T transparency, used with an 80D blue filter and with an exposure of 12 seconds at f/32.

3

architectural detail

Some of the most interesting architectural pictures are created by focusing on detail. This can involve a particular feature, such as a doorway or a statue, or it can be abstract, a pattern or texture, a shape or a form. Take a fresh look at your subjects and use your imagination.

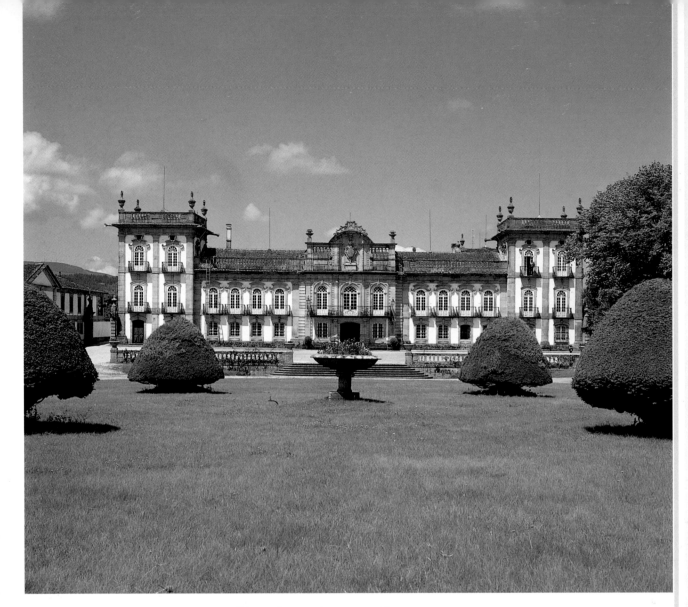

This exterior was taken as an establishing shot of the Palace of Brejoeira. Carlos Cezanne photographed the building and grounds in bright sunlight, using the neatly clipped topiary to create foreground interest and lead the eye towards the main entrance of the house. When shooting a portfolio of pictures for an assignment, general views like this help to create a context for both interior and exterior detail shots.

technical details

Rolleiflex 6008 camera with a 50mm lens. Film was Kodak Ektachrome 100, used in available daylight.

Tip

It's always advisable to bracket when using transparency film, especially in difficult lighting conditions: varying the exposure, normally in increments of half a stop up and down, greatly improves the prospects of getting an acceptable result. Sometimes a slightly lighter or darker exposure is preferable to the one recommended by the meter reading. Bracketing is not so essential when using colour negative or black-and-white film. These materials are much more tolerant of minor errors than transparency film and also allow images to be tweaked at the printing stage.

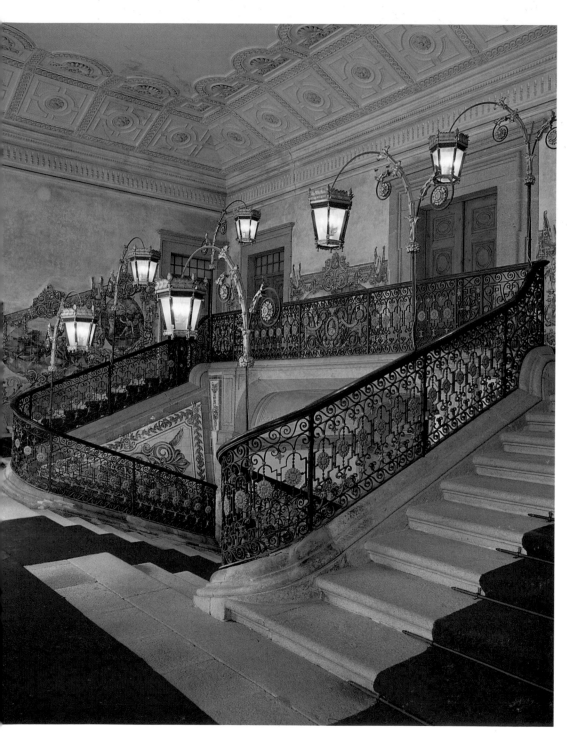

Composition

Carlos Cezanne photographed the Palace of Brejoeira, a magnificent edifice located in the wine-growing area of northern Portugal, for an interiors magazine. In this shot his subject was the building's grand central staircase, with its intricate ironwork and sumptuous tilework set off by the rich red of the carpet. Using a 6x6cm medium format camera gave him a square image and he composed symmetrically, positioning the balustrades in the centre of the frame.

Lighting

Cezanne relied on ambient lighting for this shot: a combination of daylight falling into the interior and illumination from the ornate lamps on either side of the staircase. He never uses flash for interior shots, and in this case was also able to dispense with the reflectors he sometimes uses to fill in dark corners. As always, however, he bracketed his shots, making a series of exposures either side of the setting recommended by the meter reading. A solid tripod gave him the stability demanded by a long exposure of around 15 seconds.

technical details

Rolleiflex 6008 camera with an 80mm lens. Film was Kodak Ektachrome 100, with an exposure of around 15 seconds at f/16.

Technique

The best way to pick out detail and texture is with sidelighting, and this can be provided either by natural daylight falling at an oblique angle or by artificial flash. Angelo Hornak used two flash heads to illuminate this exotic beast carved on a capital in the Norman crypt of Canterbury Cathedral. "This is stone, but the same technique can be used for wood, cloth or any other texture," he says. He used a 5x4in Linhof camera with a 240mm lens – a short telephoto equating to around 80mm in 35mm format.

Lighting

Hornak set up his main flash to the right of the camera to provide a raking light, at an angle as acute as he could make it – not quite 90 degrees, he calculates, but at least 80. This undiffused key light created strong contrast, with the highlighted areas of the carving casting dramatic shadows. However, he didn't want pockets of total darkness so he placed a second flash head to the other side of the subject, just behind the camera, to act as a fill light. This was set to quarter-power and bounced from an umbrella, but was enough to even out the shadows. The crypt was dark and, with the shutter set to synchronise with the flash heads, the background appeared perfectly black.

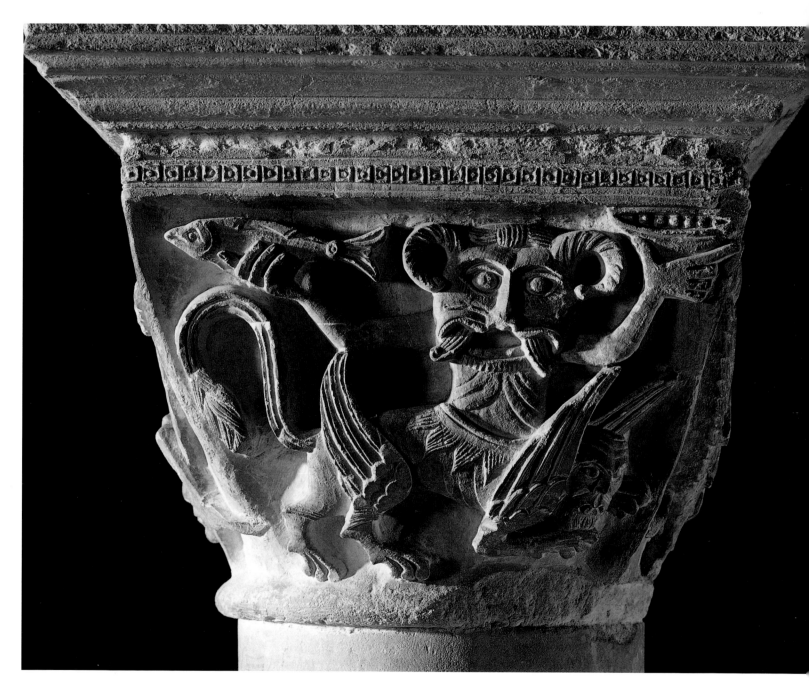

technical details
Linhof 5x4in camera with a 240mm
Symmar lens. Film was Kodak
Ektachrome 100, with an exposure of
1/125sec at f/16, using two flashguns.

Composition

This spectacular spiral staircase is to be found in Antonio Gaudí's church of the Sagrada Familia in Barcelona. Shooting in a confined space, in low lighting conditions, made life difficult for Kobi Israel. He couldn't set up a tripod in the narrow stairwell so instead had to rest the camera on its back on a ledge, with the lens pointing upwards. The unorthodox camera position meant that he couldn't see through the viewfinder, so he had to compose the shot blind.

Technique

Israel took a number of different shots, but this one worked the best. He used a small aperture to ensure maximum depth of field but, as the correct exposure was difficult to judge, he experimented with a range of different shutter speeds, from two seconds up to four seconds. At such long exposures the camera had to be kept absolutely still, so he used the self-timer to fire the shutter each time.

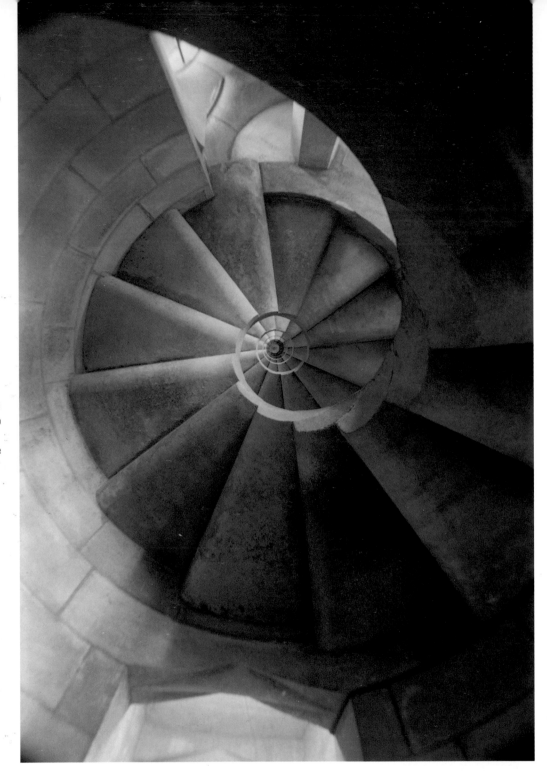

technical details
Canon EOS 5 camera with a 28-105mm zoom lens. Film was Fujicolor ISO 100 print film, with an exposure of several seconds at f/11.

This spiral staircase is a central feature of the Derozhinskaya mansion in Moscow. Igor Palmin photographed it as part of a commission for a book project, and exaggerated its plunging perspective by pointing his 5x4in camera straight down the stairwell. The ambient lighting was good enough for Palmin to work in without any additional lighting equipment.

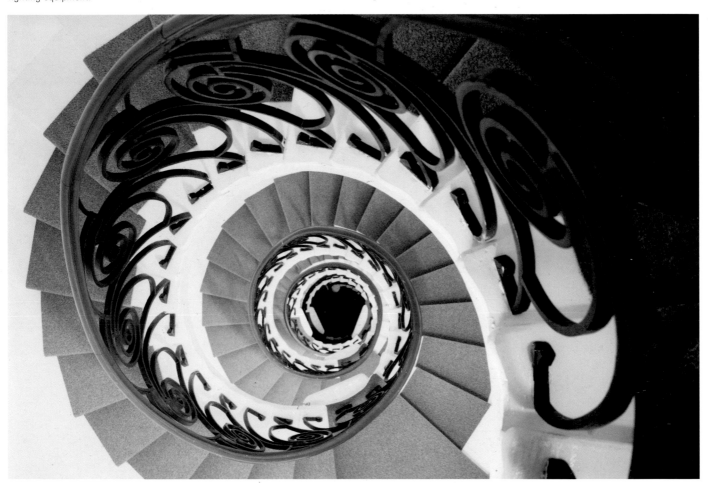

technical details
Linhof Technikardan 5x4in camera with a Fujinon 75mm lens. Film was Kodak Tmax 100, and the exposure was made in ambient lighting conditions.

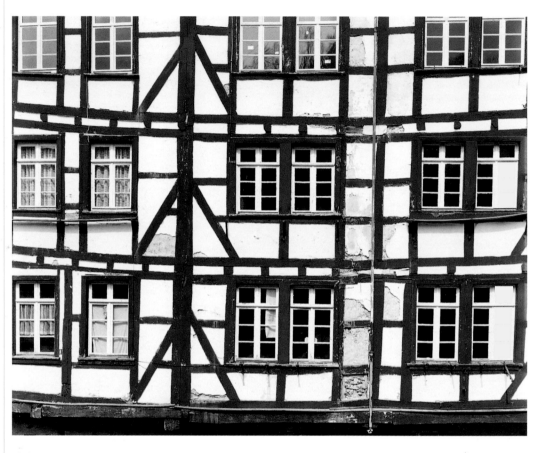

technical details
Deardorf 10x8in camera with a
360mm lens and Kodak Tmax 100
film. Exposure of 1/2sec. Contact
printed onto Ilford FB Grade 3 glossy
paper and selenium-toned.

On a day trip to the historic town of
Monchau, not far from his home in
Germany, William Jackson spotted
the graphic patterns formed by the
windows and timber framing of this
old house. Using a 10x8in Deardorf
camera, he cropped in tightly so that
the composition was symmetrical. At
this time, Jackson sold most of his
pictures to US military personnel
who wanted reminders of their
European tours of duty. He didn't
think this picture would appeal to his
clients, but took it for his own
enjoyment instead.

Lighting

William Jackson seeks out subjects that other photographers might simply ignore. He passed this tree on his way to work every morning for two or three months while based in Germany and mentally filed it as a subject with good potential once the lighting was right. One sunny late morning he drove back in his lunch break to find that the lighting was perfect. A few hours later the day had turned dull again and the scene was back in shadow.

Composition

Jackson set up his 10x8in Deardorf camera on the pavement in front of the house and cropped in tightly on the tree, framing so that the four windows behind it formed a symmetrical pattern. His idea was to show the harmonious relationship between building and Nature. The street was quite busy, so he had to put up with numerous interruptions from passing pedestrians.

Printing

In the darkroom, Jackson wanted a warm print with rich tones. As with the picture opposite, he put the 10x8in sheet negative into a contact print holder and contact printed directly onto a sheet of Ilford Multigrade FB, a fibre-based paper with rich, dark tones. Once developed, he finished off the print by selenium-toning it in a 30:1 dilute solution.

technical details

Deardorf 10x8in camera with a 360mm lens and Kodak Tmax 100 film. Exposure of 1/2sec. Contact printed onto Ilford Grade 3 FB glossy paper and selenium-toned.

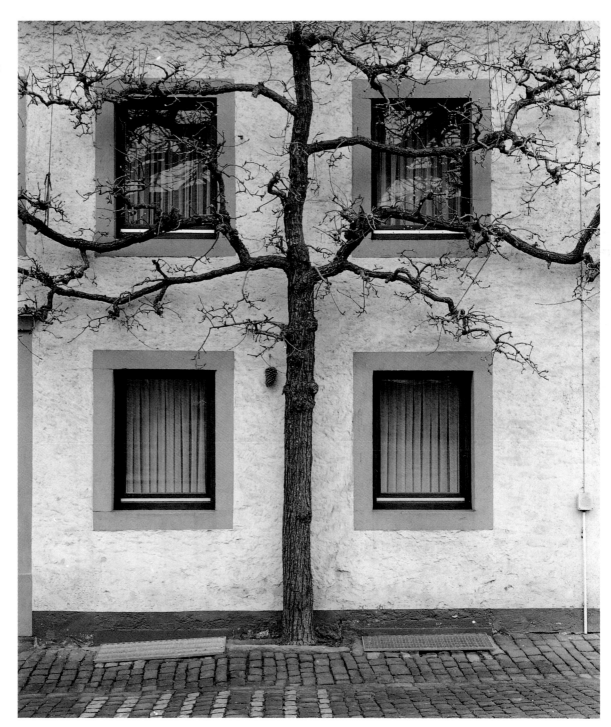

Composition

Morten Heiselberg stumbled across this doorway in an Oxford college while shooting a photo essay on the city. Struck by the lines and shadows of the empty quadrangle, he used the doorway as a natural frame. The flagged pathway led the eye to the door opposite and the shadow cast by the roof created a strong diagonal that neatly bisected the frame, making a geometrical composition with interesting contrasts of light and dark, sunlight and shade.

Technique

When photographing buildings, Heiselberg shoots his main pictures on 5x4in to get the best-quality images he can. Once he's done that, he uses smaller-format cameras, such as 6x6cm, to record the details. When necessary, he retouches his pictures in Photoshop – for example, getting rid of unwanted reflections in windows or removing distracting objects from in front of a building.

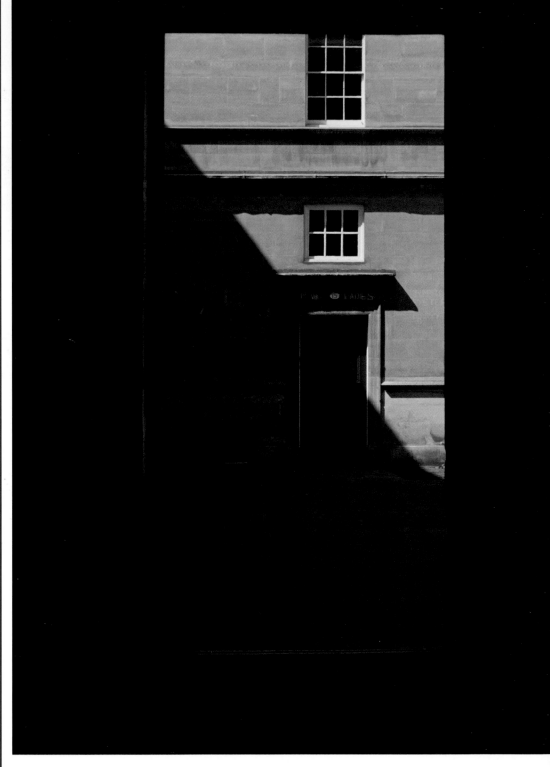

technical details

Bronica SQA1 camera with an 80mm lens. Film was Ilford Pan F+, developed in ID-11, with an exposure of 1/125sec at f/8.

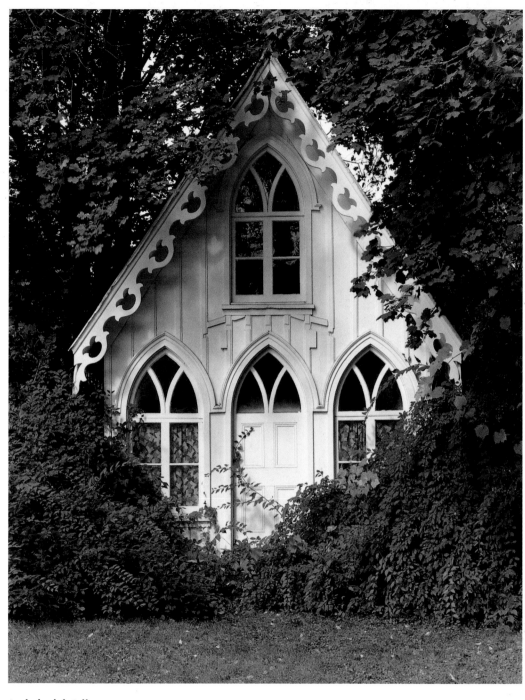

This curious, overgrown building, which Robert Zeichner found on an estate in Milesburg, Pennsylvania, was known simply as 'The Gothic'. Once a servants' cottage, it was being used as a storage shed – although it looked more like something out of a fairytale. Lighting conditions were variable, with occasional sunshine, and Zeichner waited for the sun to disappear behind a cloud before taking the shot. This cut down the contrast and eliminated a number of distracting shadows.

technical details
Wisner Traditional 5x4in camera with a 210mm Xenar lens. Film was Kodak Tmax rated at ISO 240, with an exposure of 1/4sec at f/45.

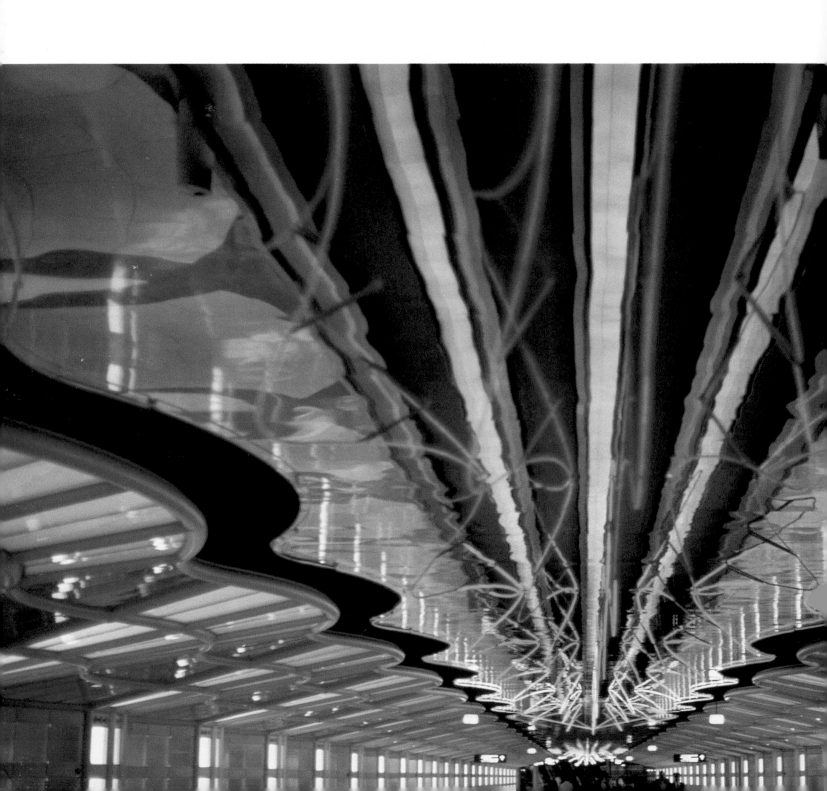

Composition

Steve Warble was attracted by the colours and patterns of the ceiling in the futuristic United Airlines Terminal at O'Hare Airport in Chicago. He shot handheld, using a 35mm SLR fitted with a 28mm wide angle lens, and framed so that the red and orange colours at the far end of the concourse provided a focal point from which the wavy lines and cooler colours seemed to explode. The travellers on the moving walkway at the bottom of the frame provided a point of reference and a sense of scale.

Technique

Warble usually carries a tripod but reckons to use it only about 25 per cent of the time. When hiking he carries a lightweight Slik tripod in his backpack; in his car he carries a sturdier Bogen model at all times. A tripod is at its most useful with a zoom or other telephoto, as heavier lenses are more likely to cause camera shake. Wide angles are not only lighter but also tend to have larger maximum apertures, meaning that they can be used in much dimmer lighting conditions before there is a risk of subject movement. Here there was enough light to dispense with the tripod, even though Warble was shooting indoors and using relatively slow film.

technical details

Pentax Spotmatic II camera with a 28mm lens and Kodachrome 64 transparency film. Handheld using available light.

Tip

Most of the time you will encounter no problems in taking pictures of airport buildings, but in some places photography is banned for security reasons. The same goes for bridges, power plants and other strategic pieces of infrastructure – and especially for police stations, border posts and any building with a military connection. Be aware of local political sensibilities when travelling abroad, and respect any restrictions that may be in force. It's better to lose a potential picture than end up in a police station. At best you will face an awkward interview, at worst you risk having your equipment confiscated – and perhaps even spending some time in a cell.

Composition

Some details can only be appreciated by looking up, and Angelo Hornak had to lie on the floor of Canterbury Cathedral to line up this shot of Bell Harry Tower. He angled his Linhof camera so that the ornate ceiling was off-centre, making the composition more dramatic.

Technique

A solid tripod was essential. "It used to be the case that your tripod had to be heavier than the camera, or it wouldn't hold it steady," says Hornak. "That's no longer true with the latest carbon-fibre models, but a good tripod is still very important."

Lighting

The 150mm lens – a standard focal length in 5x4in format – gave a limited depth of field, so Hornak had to stop the aperture right down to f/16. This gave him an exposure of 20 seconds which, with daylight-balanced film, would be in the danger zone for reciprocity failure, which can lead to unpredictable colour casts. However, here he used tungsten film with an amber 85B tungsten-to-daylight conversion filter. The fan vaulting was illuminated by the mid-morning light streaming in through the tower windows. "It was all natural daylight," says Hornak. "It was lit by the architect."

Tip

Reciprocity failure can be a problem when using daylight-balanced film for long exposures indoors. "Daylight film is balanced for exposures of 1/60sec or for flash, and after that the colours start to break down," explains Angelo Hornak. "The colour curves are balanced differently, so in one situation you might lose green, in another blue. In the old days you would use tungsten film and an amber filter to balance up the daylight, but fortunately modern films are much more forgiving."

technical details

Linhof 5x4in camera with a 150mm lens. Kodak Ektachrome 64T tungsten film, with an exposure of 20 seconds at f/16, and an 85B tungsten-to-daylight conversion filter.

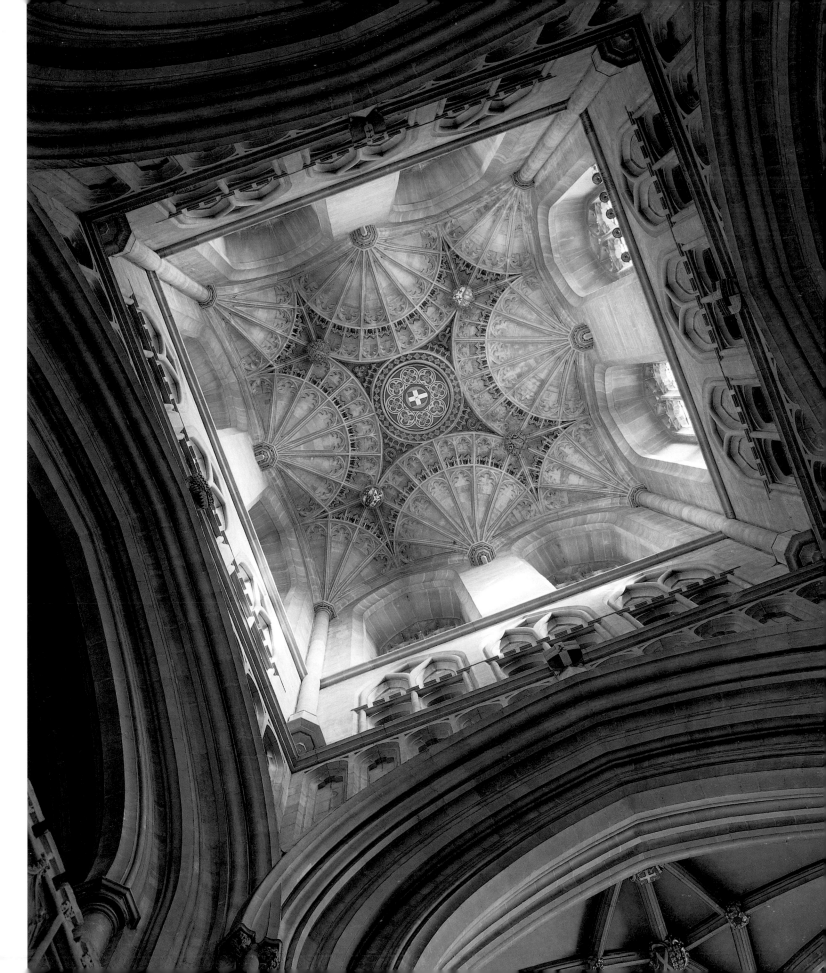

When Robert Zeichner photographed the First Congregational Church in Bennington, Vermont - the resting place of poet Robert Frost - his options were limited by dull lighting conditions and a steady drizzle. Homing in on the textures of the gravestones and the white clapboard building, he took shelter under a large maple tree, which doubled as a 'visual umbrella' for the top of the frame. He aligned the verticals correctly by adjusting the rising front of his Wisner camera and also applied some rear swing, which altered the plane of focus and reduced the depth of field needed to keep everything sharp.

technical details
Wisner Traditional field camera with a 210mm Symmar-S lens. Film was Kodak Tmax rated at ISO 240, with an exposure of four-and-a-half seconds at f/45.

Composition
These weathered stone steps, in the formal gardens of the Villa Vizcaya in Miami, Florida, were rich in texture, particularly when seen in combination with the intricate pattern created by the light filtering through the trees. "The mottled light seemed very appropriate for the stucco-like texture of the stairway," recalls Robert Zeichner. He set up his large format camera on level ground just in front of the steps and adjusted its rising front to ensure that the verticals were recorded accurately.

Lighting
With black-and-white film rated at ISO 240, Zeichner used a yellow filter to darken the sky slightly and increase contrast. The bright sunlight helped to create a punchy negative, and in the darkroom he was able to make a relatively straightforward print. Only the top edge of the frame and the bottom right-hand corner required a little burning in, to deepen the dark tones and boost contrast levels.

technical details
Wisner Traditional field camera with a 135mm Nikkor-W lens. Film was Ilford Delta 400, rated at ISO 240 and used with a yellow filter, with an exposure of around 1/8sec at f/22.

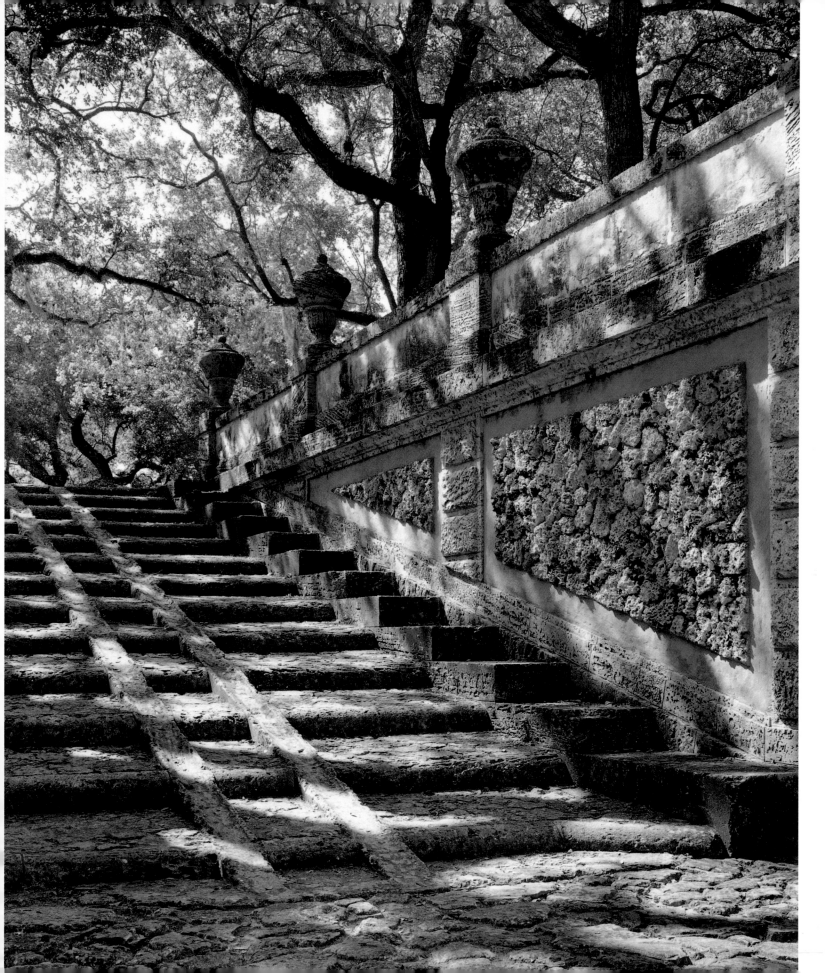

Composition

Fine art photographer Gregoire specialises in 'found' architectural scenes, and shapes and textures play an important part in his compositions. He took this picture at one of his favourite locations, an abandoned farm in Connecticut, New England. Attracted by the asymmetry of the sagging wooden barn, he cropped in on the clapboard façade and the zig-zags of the door frames. The angularity of the building had been softened by decay – almost, he thought, as though it had 'relaxed'.

Lighting

Gregoire only ever works with natural light, and for his architectural work invariably shoots in black-and-white. For this shot he used a number 8 filter – a pale yellow filter which, with black-and-white film, darkens blue tones. It has a similar effect to red filters, which boost contrast in sunlit scenes and darken expanses of blue sky, making them appear almost black.

Technique

He framed the picture tightly, using a large format camera and slow black-and-white film for maximum detail. Black-and-white is ideal for emphasising textures and patterns, whereas colour can sometimes be a distraction. This picture has a wistful, melancholy feel to it, but there is an upbeat postscript – Gregoire reports that the old farm now has a new owner who is renovating the buildings.

technical details

Omega 5x4in view camera with a Schneider 150mm lens. Kodak Tmax 100 sheet film with a number 8 yellow filter.

"I try to incorporate the impact made by a building's occupants, which completes what the architects and builders began."
Gregoire

Gregoire shot these locked and empty beach cabins at Clinton, Connecticut, in the depths of winter. He was attracted by the texture of the peeling white paint, which he felt emphasised the off-season desolation of the scene. He used black-and-white film with a number 25 red filter to increase the contrast and concentrate attention on the shape and texture of the weathered boards.

technical details
Omega 5x4in view camera with a Schneider 150mm lens. Kodak Tmax 100 sheet film with a number 25 red filter.

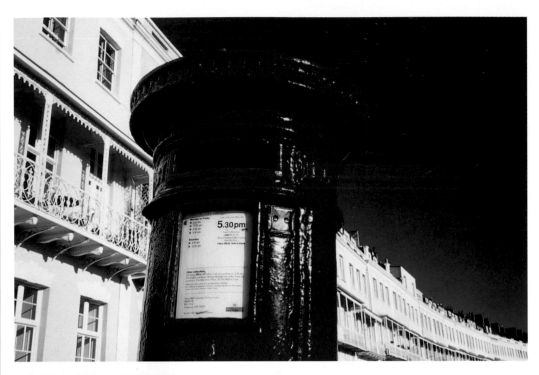

5.30pm

Canon EOS 1 camera with a
28-80mm zoom lens. Film was Fuji
Velvia, used in available daylight
with a polarising filter.

Clive Minnitt snapped this bright
red door while spending an
afternoon wandering the streets of
Bristol with his camera. The sun was
sinking fast so he had to work quite
quickly, taking the shot before the
shadow cast by the railing rose to
cover the letter box.

technical details
Minolta X-300 camera with a 28-
210mm zoom lens. Film was
Kodachrome 64, used in available
daylight.

Composition
The strong combination of red, white
and blue attracted Clive Minnitt to
this pillar box in Clifton, Bristol. He
also liked the way the curves of the
box complemented those of the
buildings in the crescent, while the
indentations in its top echoed the
rows of windows stretching away
into the distance. The sky was
cloudless, which suited him perfectly
– he felt the scene was busy enough
as it was.

Lighting
When he arrived, in the middle of
the afternoon, the whole of the pillar
box was covered in shadow cast by
a nearby tree, which made it appear
too dull. So he waited for the sun to
move around and the shadow to
clear, using the time to try out
different compositions. A polarising
filter deepened the colours –
especially the blue of the sky – and
boosted contrast.

Clive Minnitt's checklist

Plan ahead. A phone call can establish whether a building is undergoing renovation or cleaning, is hidden under scaffolding or is simply closed.

Decide whether the sky adds anything to the picture. It's sometimes best to leave it out altogether. Watch out for vapour trails left by aircraft.

Be careful not to include unwanted shadows – including your own.

If the light is good but changing rapidly, take a few quick shots anyway. You'll at least have something in the bag.

Beware vignetting when using filters and watch out for flare caused by direct sunlight on the lens.

Use foreground interest to lead the eye to the main subject, but don't clutter the frame with unnecessary detail.

When photographing on spec, check out local bookshops and postcard sellers. Don't necessarily copy what you find – try to improve on it.

Check your equipment thoroughly before setting off for a distant location. It's better to prevent problems than to have to react to them.

Always carry more film and batteries than you think you'll need.

Take film stock of different speeds. Weather forecasts are not infallible!

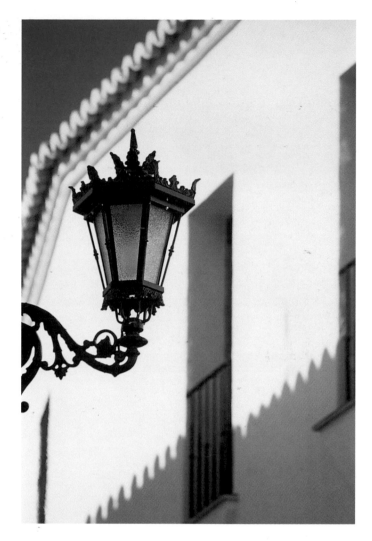

Details can often be as telling as entire buildings. When Clive Minnitt photographed this ornate streetlamp in Andalucia in Spain, the sun was casting strong shadows on the wall behind. He cropped in carefully so that the lamp was picked out against a plain white section of wall, and made it stand out further by choosing a wide aperture, which threw the rest of the scene out of focus.

technical details
Canon EOS 1 camera with a 100-300mm lens. Film was Fuji Velvia, used in available daylight with a polarising filter.

Geometrical precision and highly polished materials attracted Adam Hoffberg to photograph this exterior wall at the Museum of Contemporary Art in Chicago. The essence of the composition was squares and right angles and, to keep the lines parallel, he used a 50mm perspective control lens on his medium format camera. He shot in available daylight, with the camera mounted on a tripod. Although the negative was in 6x4.5cm format, Hoffberg cropped the image square at the printing stage to emphasise the geometrical motif.

technical details
Mamiya 645 camera with a 50mm perspective control lens. Film was Agfapan 100, with an exposure of 1/4sec at f/8.

Composition
"By eliminating the distraction of colour, black-and-white emphasises form and structure and is particularly well suited to modern architecture with its rationalist geometry and monochromatic palettes," says Adam Hoffberg. The white-walled interior of the Museum of Modern Art in San Francisco, with its gentle curves and sharp angles, provided him with a perfect subject. Strong sunlight filtering through a skylight created an intricate pattern of shadows, together with contrasting areas of light and dark.

Lighting
Hoffberg shot handheld with a 35mm SLR and a telephoto zoom, and used a fast black-and-white film to achieve a sharp though slightly grainy image. He emphasised the graininess by enlarging the image significantly at the printing stage, and boosted the contrast between the light and dark areas by using a high-contrast paper, which gave deep blacks and pure whites.

Printing
When printed straight, the high-contrast paper rendered the shadows far too light, with some of them barely registering. Hoffberg therefore had to burn in each shadow with different levels of exposure. The black area in the bottom right-hand corner was a hallway, which had a small recessed light that spoiled the pure black effect he was searching for. He overcame the problem by making a template that covered the paper in the enlarger easel but cutting a small hole at the point where the light appeared. Using a flashlight, he then burned in the area around the light to remove this detail completely from the finished print.

technical details
Canon 35mm SLR camera with a telephoto zoom lens. Film was Kodak Tri-X, with an exposure of 1/60sec at f/8.

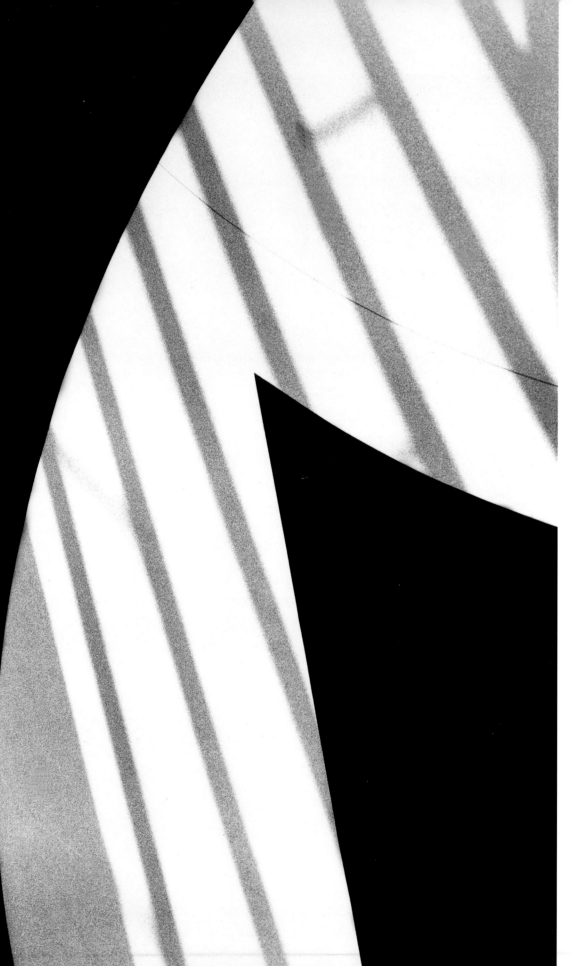

"By eliminating the distraction of colour, black-and-white emphasises form and structure."

Adam Hoffberg

Composition

Scott Pearson used his wits for this night-time shot of Sloppy Joe's, a landmark venue in Florida's Key West. He was faced with two main problems: firstly, the street was clogged with traffic; and secondly, the bystanders on the pavement were just as curious about what he was doing as about what was going on inside the bar. He solved these problems by enlisting the help of the bar manager and a couple of customers. The manager made an announcement that got everyone peering in through the windows, while the locals briefly stopped the traffic in both directions when he was ready to shoot.

Technique

With his camera and tripod set up on the pavement across the road, Pearson had a good view of the bar but felt the shot lacked foreground interest. To remedy this he borrowed a hosepipe, with which he sluiced down the roadway. The wet tarmac reflected the light of the neon signs, adding extra detail.

Lighting

Setting his zoom to its wide angle setting and the aperture to f/16, Pearson set about bracketing his exposures to guarantee that at least one of the long exposures would work. He selected the bulb (or 'B') setting on the shutter speed dial and held the shutter open with a cable release, making a series of exposures that ranged from five seconds up to 25 seconds.

technical details

Canon EOS 1N camera with a 28-105mm lens set at 28mm. Film was Fuji Velvia, with a series of exposures bracketed between five seconds and 25 seconds at f/16.

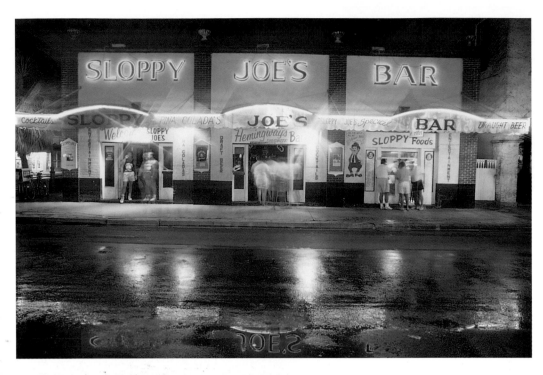

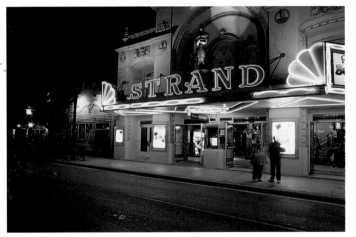

Scott Pearson shot the art deco façade of the Strand Theater in Key West, Florida as part of an assignment for a travel magazine. He set up his tripod between two parked cars on the opposite side of the street, and selected the 'bulb' setting on the camera's shutter speed dial. He then took a series of shots, bracketing the exposure times between one and six seconds.

technical details

Canon EOS 1N camera with a 17-35mm lens set at 24mm. Film was Fuji Provia, with exposures bracketed between one second and six seconds at f/16.

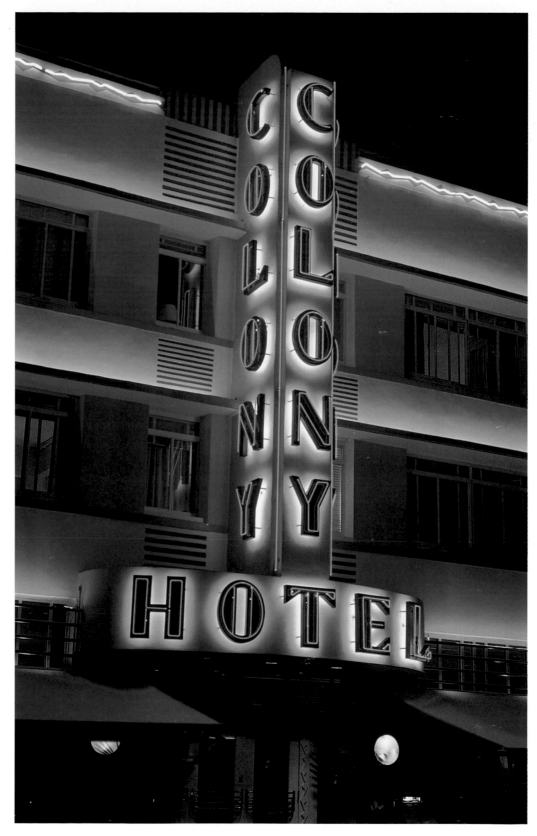

Taking pictures for a magazine article about Miami's South Beach, Scott Pearson homed in on the neon sign of the Colony Hotel, a well-known local landmark. With the camera secured on a heavy tripod, he set his camera to manual and the aperture to f/22. He then bracketed his exposures from two seconds up to eight seconds. "The key to this photo is a slow-speed film with good colour saturation that won't shift under long exposures and a good tripod that will hold steady even in a 20-knot breeze," says Pearson.

technical details
Canon AE2 camera with a 70-200mm lens set at 200mm. Film was Fuji Provia, with exposures bracketed between two and eight seconds at f/22.

assignments

A structured approach is essential to get the most from any subject, whether you are working to a brief or pursuing a personal project. The following examples show how three photographers dealt with a selection of different subjects, involving interiors and exteriors, historic and modern, and with very different purposes in mind.

"These pictures represent an attempt to create a graphic language of photography."

Mario Guerra

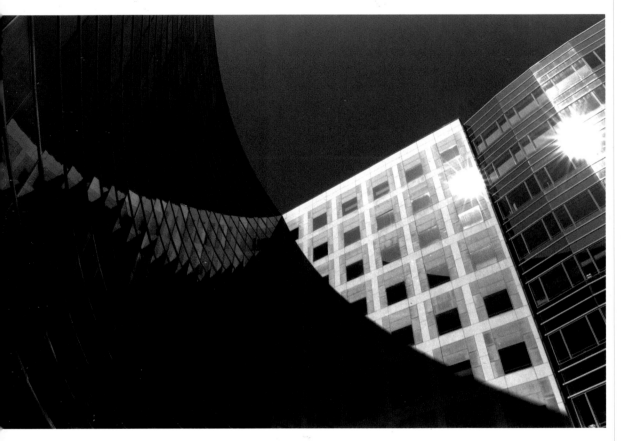

Approach

Mario Guerra is often commissioned to photograph buildings, though his architect clients invariably want straightforward record shots. When he is working on his own personal assignments, he allows himself to be more creative. This set of pictures was taken at La Défense, the business district on the western outskirts of Paris. Guerra gave himself free rein to interpret the spectacular modern architecture in a purely photographic manner, using the lines, curves and surfaces of the buildings to create a series of abstract compositions. "These pictures represent an attempt to create a graphic language of photography," he says.

technical details
35mm Nikon SLR with a 24mm Nikkor lens. Film was Kodak Tmax 100, with an exposure of 1/125sec at f/16.

Composition

Using 35mm gear on account of its portability, Guerra roamed for hours around the complex, searching out graphic juxtapositions and photographing the same buildings from a number of different angles. For this shot, taken behind the structure known as the Grande Arche, he used a wide angle 24mm lens and pointed it upwards, deliberately allowing the verticals to converge for effect. Exposing correctly for the brightly lit upper section of the tower block meant that detail was lost in the building in the foreground, making it a solid, dark shape that filled the left-hand third of the frame.

technical details

35mm Nikon SLR with a 24mm Nikkor lens. Film was Kodak Tmax 100, with an exposure of 1/125sec at f/16.

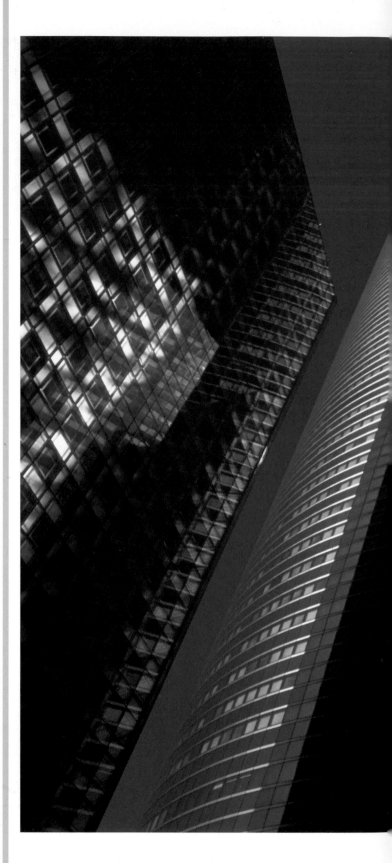

Technique

For most of his pictures of La Défense, Mario Guerra used black-and-white film to emphasise the abstract nature of the shapes and lines of the buildings. However, for certain shots he switched to colour transparency film to capture the buildings in their full glory. He composed this shot as symmetrically as he could, with the rhomboid building at the front placed right at the centre and the twin towers rising behind it. Although he was using a perspective control lens on his 35mm camera, he allowed the verticals to converge towards the top of the frame. This, in combination with the wide angle of view, created a dizzying sense of the buildings crowding in on the camera position.

technical details

35mm Nikon SLR with a 28mm perspective control Nikkor lens. Film was Fujichrome Provia 100, with an exposure of 1/125sec at f/16.

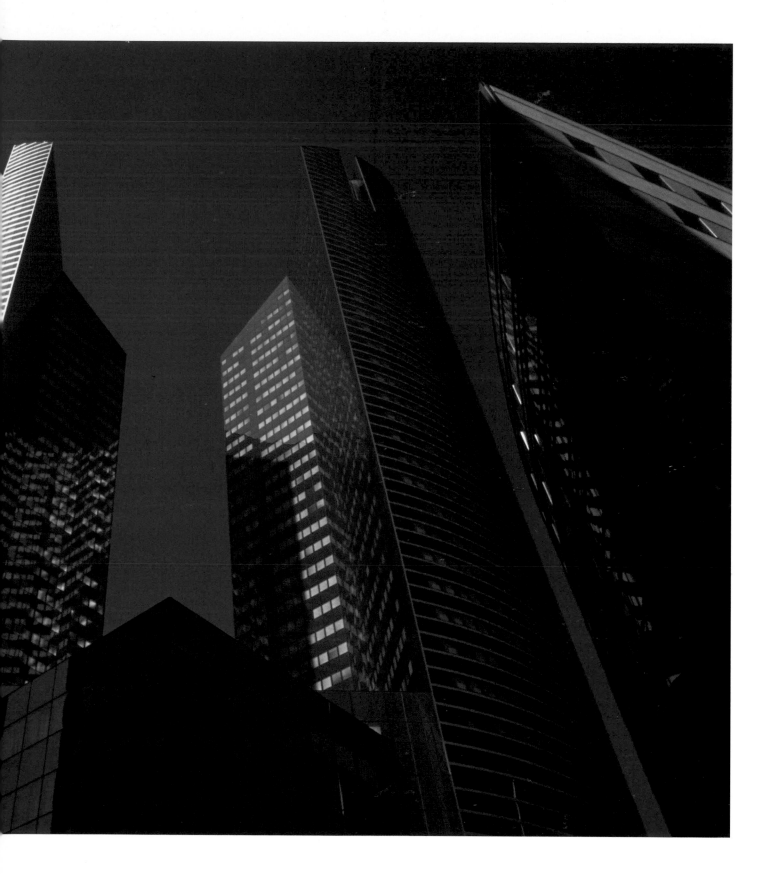

Mood

For Mario Guerra, architectural photography is a very personal matter. His pictures are strongly influenced by lighting conditions, by the atmosphere of the location and by his own emotional response to it. Music is an important part in his inspiration and he often visualises his shots with a piece of music in mind. This shot represents a change of pace from his other studies of La Défense: instead of taking the sweeping wide angle view, he used a zoom lens to crop in tightly on a small section of a building. The power of the shot lies in the way the graphic vertical and diagonal lines combine with the fragmentary details reflected in the glass panels.

technical details

35mm Nikon SLR with an 80-200mm Nikkor zoom lens. Film was Kodak Tmax 100, with an exposure of 1/500sec at f/5.6.

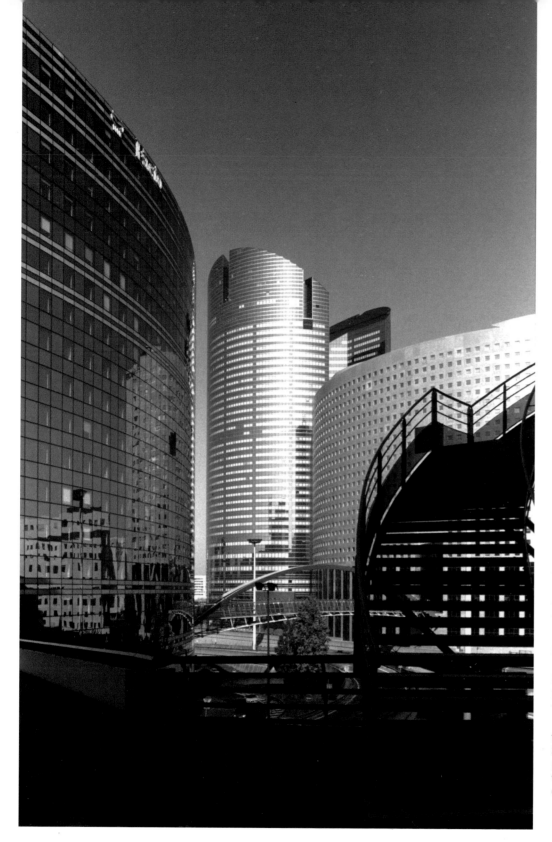

Composition

For this shot, Mario Guerra took the opposite approach, shooting from a distance and using a wide angle perspective control (or tilt and shift) lens, which allowed him to include a large area of the complex and to align the verticals correctly. Despite these verticals the picture is full of curves, right down to the staircase in the lower right-hand corner of the frame, which is placed on an intersection of thirds and which provides a strong point of foreground interest. A small aperture of f/22 meant that virtually the whole of the picture was in sharp focus, from the front of the frame to the back.

technical details

35mm Nikon SLR with a 28mm perspective control Nikkor lens. Film was Kodak Tmax 100, with an exposure of 1/60sec at f/22.

"Discuss the assignment in advance with the client. Make sure you know what they consider important and ensure that you capture this in your pictures."

Koen van Damme

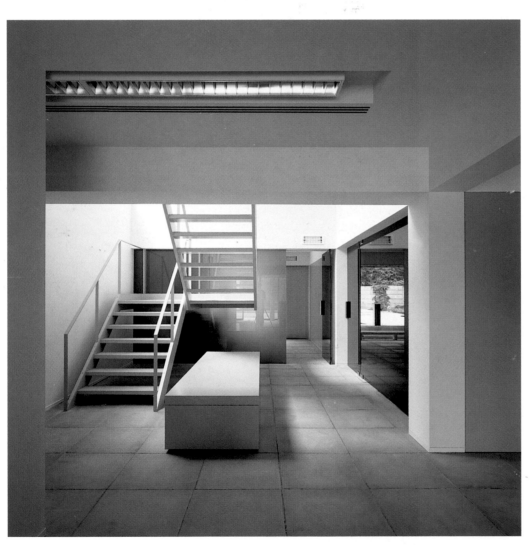

Preparation

Koen van Damme is particularly attracted to the cool, clean lines of modern architecture. This assignment, to photograph a new Bacob bank building in Kalmthout, Belgium, was undertaken on behalf of the Vincent Van Duysen firm of architects. The company specialises in minimalist, stripped-down design and van Damme's brief was to capture the essence of this in the photographs.

Briefing

Van Damme always makes sure that he and his clients are both absolutely clear about what an assignment will involve before he gets down to work. "Discuss the assignment thoroughly in advance with the client," he advises. "Make sure you know what they consider important and ensure that you capture this in your pictures."

technical details

Hasselblad FlexBody view camera with a 60mm lens. Film was Kodak Ektachrome 100 SW, used in available daylight.

Composition

According to Koen van Damme, architectural photography revolves around four concepts: light, structure, space and proportion. Once he's been briefed on a job, he examines the building with these four ideas in mind, and asks himself a number of questions. Is the space open or enclosed? Is there anything in it that might prevent him taking a good architectural picture? If so, can it be removed – and if it can't be removed physically, could it be digitally removed later on? He then looks at the forms and structures of the building, assessing how important each one is and how they all hang together. He also scouts the area around the building, establishing the best viewpoints for exterior shots. "There are a lot of questions that need to be answered in a very short time," he says, "but the aim is to get down to the essence as quickly as possible."

technical details

Hasselblad 903SWC camera with a 39mm lens. Film was Kodak Ektachrome 100 SW, used in available daylight.

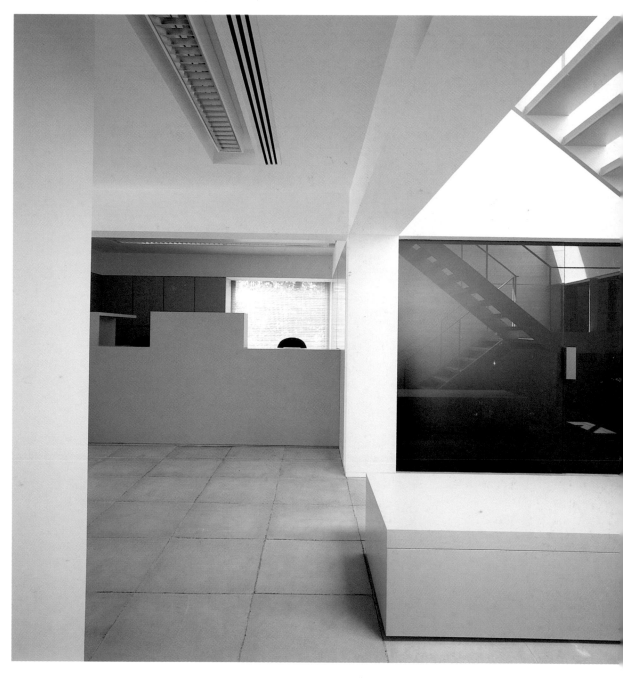

Planning

It's important to establish the size of the budget for a particular job, says Koen van Damme, and how long it should take to complete. Bear in mind that weather conditions may throw a spanner in the works, especially if you're shooting exteriors, and that you may have to devote more time to a project than anticipated. One important question to ask at the beginning is whether or not the building is finished: it may seem obvious – until you get there – but it can make a big difference to exterior photographs. "To a great extent the quality of your photographs depends on preparation," says van Damme.

technical details

Hasselblad 903SWC camera with a 39mm lens. Film was Kodak Ektachrome 100 SW, used in available daylight.

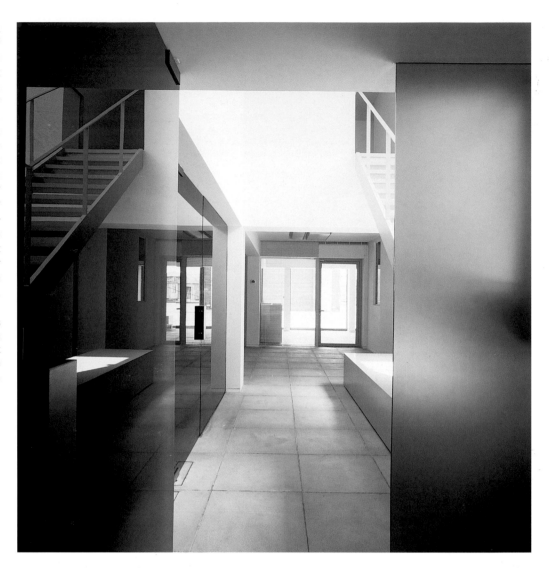

"To a great extent the quality of your photographs depends on preparation."

Koen van Damme

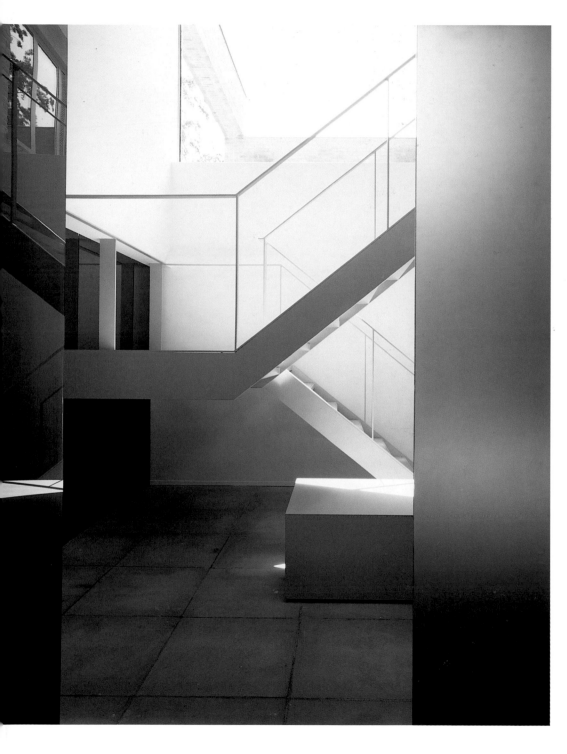

Composition
Koen van Damme shot all the interiors for the Bacob assignment 'front on' so that the planes and axes of the architect's design were clearly apparent. In these two pictures, he focused attention on the glass curtain wall behind the building's central staircase. This had a twin purpose: it emphasised this important design element, but it also provided him with a ready-made framing device that gave shape to the composition.

Lighting
Changing lighting conditions completely alter the way a building looks. Van Damme works exclusively with available light – either natural daylight or the building's own ambient lighting, or a combination of the two. He dislikes artificial light sources such as flash. This is primarily because he considers the results they give to be unnatural but also because they are fiddly and time-consuming to use – and inevitably add to the costs.

technical details
Hasselblad 903SWC camera with a 39mm lens. Film was Kodak Ektachrome 100 SW, used in available daylight.

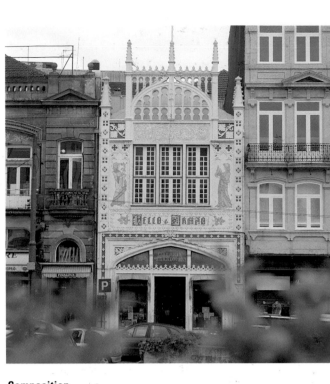

technical details

Rolleiflex 6008 camera with a Rollei Distagon f/1.4 50mm lens. Film was Kodak Ektachrome 100, with an exposure of around 1/15sec at f/11.

Composition

Commissioned to shoot the historic Lello bookstore in Porto for an interiors magazine, Carlos Cezanne began by taking an establishing shot of the exterior of the building. The day was dull and overcast, giving soft, even lighting. Cezanne included a few sprigs of foliage at the bottom of the frame but threw them out of focus. The leaves created a natural frame that helped to add a feeling of depth to the picture – and also had the useful effect of masking out some of the traffic cluttering the street in front of the building.

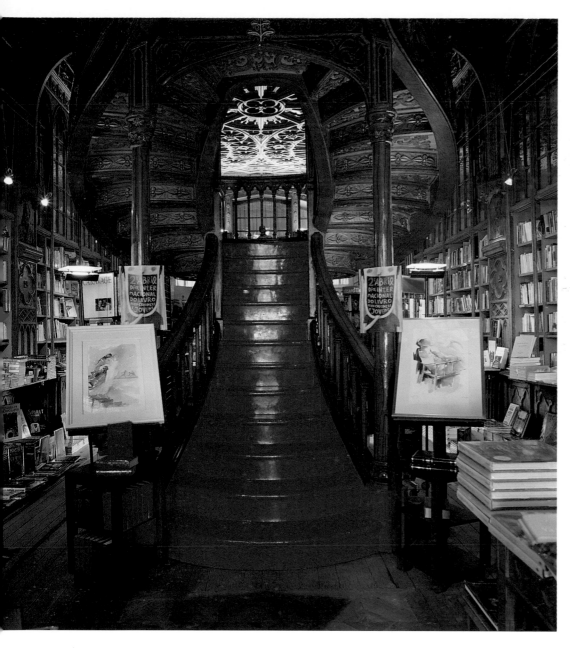

Equipment

Moving inside, Cezanne began by tackling the ground floor of the bookshop and the sweeping staircase leading up to the first floor. He uses two 6x6cm medium format Rolleiflex camera bodies for his architectural assignments (a Rolleiflex 6008 Professional and a 6008 Integral) and carries a selection of Rollei lenses: a 50mm, an 80mm, a 120mm macro and a 180mm. Reflectors, close-up accessories, a flash meter and – most importantly – a sturdy Gitzo tripod complete his kit.

Lighting

For both interior and exterior shots Cezanne uses available daylight almost exclusively, but for wideangle shots he occasionally supplements it with a pair of Bowens flash heads (400-watt and 500-watt), which he uses to pick out details. At night he shoots with tungsten film and if neon light is involved he uses special compensating filters. For this shot he used daylight-balanced transparency film. The lighting was a mixture of daylight, falling through the door and windows behind the camera and through a large glass skylight in the ceiling, and the shop's own artificial lighting. To spread the light evenly and fill out the shadows, he used three reflectors: one placed along the wall to the right of the staircase, one to the left of it and one behind it to illuminate its underside.

technical details

Rolleiflex 6008 camera with a 50mm lens. Film was Kodak Ektachrome 100, with an exposure of several seconds at f/11.

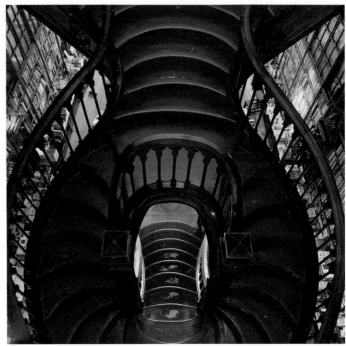

technical details
Rolleiflex 6008 camera with a 50mm lens. Film was Kodak Ektachrome 100, with an exposure of several seconds at f/11.

Technique
For this spectacular shot of the staircase Cezanne moved up to the first floor and angled the camera downwards. "I always try to shoot different angles from the obvious ones," he says. "I try to give the readers a complete impression of what the place looks like, picking out interesting details such as pieces of furniture, flower arrangements or works of art. I never leave out any element of the design – if something's there, I'll show it." He is an avid consumer of style books and interiors magazines; he finds these an excellent source of inspiration.

Lighting
To retain depth of field he used a relatively small aperture of f/11, which gave a long exposure in the available light. However, to boost the exposure and fill in the dark corners he used four reflectors. He carries a number of these, some 3ft x 6ft rectangles, others 3ft ovals. He placed two above the staircase, one on either side, and two on the floor below to throw light back up. Cezanne hates the artificial shadows created by flash, and strives always to recreate the natural atmosphere of an interior. "If there is only a candle burning I will compensate with a long exposure," he says. "You have to respect the ambience of a place."

"If there is only a candle burning I will compensate with a long exposure. You have to respect the ambience of a place."

Carlos Cezanne

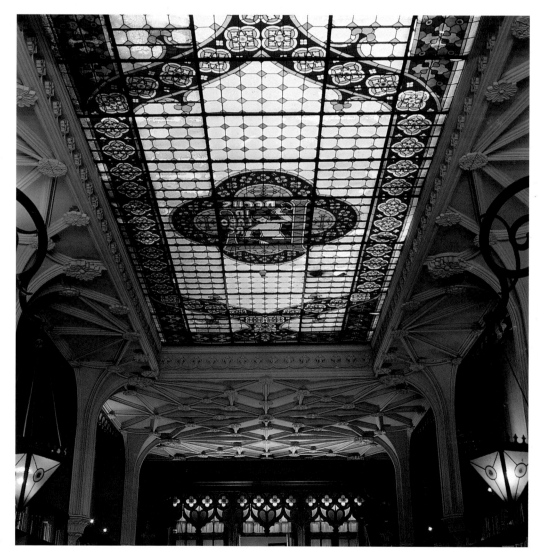

Lighting

The lighting for the shot of the painted glass ceiling was quite tricky, as Cezanne needed to balance the large bright expanse of the skylight with the artificial bulbs while retaining detail in the dark corners of the interior. He always brackets his shots, taking five exposures of each view. Two of these are set slightly below the indicated exposure reading, two slightly above. As well as providing an insurance policy against accidents, this gives him and his editorial clients more options when selecting pictures for publication. Sometimes a slightly darker – or slightly lighter – shot works better on the page than the one taken at the 'correct' exposure reading.

technical details

Rolleiflex 6008 camera with a 50mm lens. Film was Kodak Ektachrome 100, with an exposure of several seconds at f/11.

Lighting

For this shot of the first floor Carlos Cezanne used four reflectors to make the most of the daylight entering the bookshop via the glass panel in the ceiling. He placed two on the first floor, one leaning against each of the side walls, and two flat on the floor on the ground floor, to bounce the light back upwards. Here he was high enough off the ground to keep the verticals of the upper floor parallel; however, he is always ready to find a higher camera position if it will help him to avoid converging verticals. "If I have to go up three metres, particularly when shooting exteriors, up I go," he says.

Technique

When shooting interiors it's very important that the room looks its absolute best. For this reason Cezanne always insists on working with a producer, or stylist, whose responsibility is to ensure that the room is neat and uncluttered and that everything is in the right place. If the magazine he's working for can't supply one, he will hire his own. "I always insist on having a stylist; it's more important to me than having an assistant," he says.

technical details

Rolleiflex 6008 camera with a 50mm lens. Film was Kodak Ektachrome 100, with an exposure of several seconds at f/11.

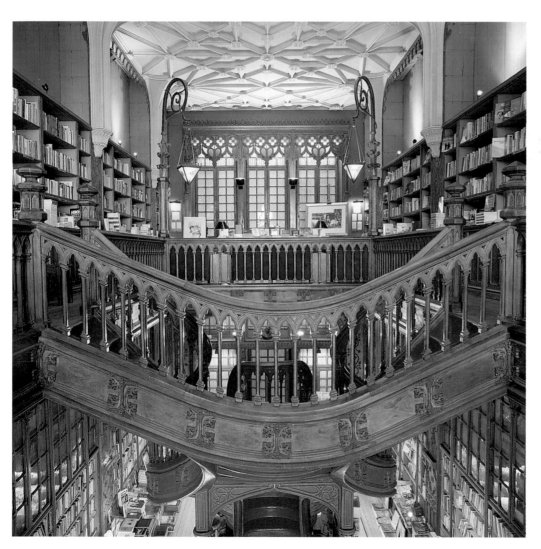

"I always insist on having a stylist; it is more important to me than having an assistant."

Carlos Cezanne

cityscapes

Buildings do not exist in
isolation, and sometimes their
context is just as interesting
as their individual detail.
Taking the wider view opens
up a whole new perspective
on the architectural
environment, and offers
opportunities for the
construction of narratives
around a variety
of themes.

technical details
Widelux F8 panoramic camera with
Fujicolor 400 colour negative film.

Equipment

Peter Marshall photographed
Stratford bus station as part of a
personal project to document the
meridian line, which runs through
Greenwich and east London. He used
a 35mm Widelux F8 panoramic
camera, which produces negatives
measuring 59mm x 24mm and covers
an angle of view of 130 degrees, or
one-third of a circle. Its design is
quite basic: it has a simple
viewfinder, a very limited range of
shutter speeds (1/15sec, 1/125sec
and 1/250sec) and a 26mm lens
which pivots around a central point
when the shutter is fired. The film
plane inside the camera is curved, and
the exposure is made though
a moving slit.

Technique

The Widelux has an ultra-wide angle
of view and an aspect ratio of 2.5:1.
The curved film plane gives a constant
lens-to-film distance over the whole
negative, which avoids the distortion
seen with extreme wide angle lenses
used on a normal camera, where
objects are 'stretched' towards the
edges of the frame. However, it does
bend horizontal lines at the
extremities, and any tilt results in a
curved horizon. This means it has to
be kept level, and it has a built-in
spirit level to make this easier.

Composition

It took Marshall a lot of trial and error
before he learned how to use the
camera properly. "I had to think
carefully about filling the whole of the
long rectangle and also avoiding the
cigar-shape distortion that occurs with
head-on views of rectangular
subjects," he explains. "The thin
rectangular format lends itself best to
linear structures. To an extent the
camera dictates its own approach to
composition and the selection of
subjects." Shooting on 35mm colour
negative film, he gets around 21
exposures out of a 36-exposure roll.

Peter Marshall shot this pedestrian footbridge over the North London Line in Stratford as part of his meridian project. Again he used a Widelux panoramic camera with Fujicolor negative film. "I look for the viewpoint where the building looks most interesting," he says. "There is something Minor White once wrote about letting the form of the subject dictate the composition, which more or less sums up the way I try to work."

Tip

Many cameras – including compacts – claim to produce 'panoramic' pictures, but most do this either by masking off part of the negative area during exposure or through selective printing. Either way, only a small area of the negative is used and the image quality inevitably suffers. It's possible to create panoramas by shooting sequences of overlapping frames and taping the prints together; artists such as David Hockney have made extensive use of this 'joiner' technique. Care must be taken with exposures so that, as far as possible, each print matches the next. It's best to use a standard lens, or even a short telephoto: a wide angle may capture more of the scene but the distortion at the edges of the frame makes it difficult to match the adjoining segments.

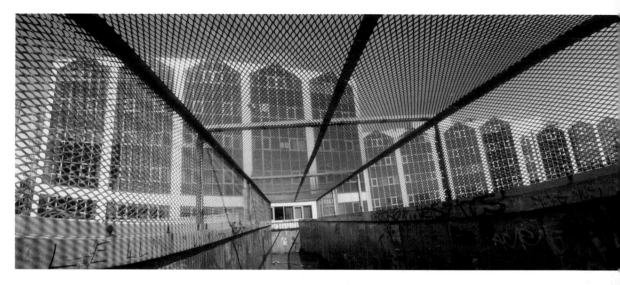

technical details
Widelux F8 panoramic camera with Fujicolor 400 colour negative film.

110 CITYSCAPES PANORAMAS

Composition

Panoramas need not always depict grand public buildings: domestic architecture can also tell a story. Peter Marshall shot this suburban road in Whipps Cross, Upper Walthamstow as part of his meridian project. Following maps, he walked north along the line from the Royal Observatory at Greenwich to Chingford in Essex, where an Astronomer Royal once built an obelisk as a marker. The meridian passed through each of the outwardly ordinary locations he photographed.

Technique

He shot with a Widelux F8 panoramic camera. The Widelux needs to be kept level and at first he used a tripod. However, this became too much of a hindrance so he learned how to work handheld. The camera has a built-in spirit level, but this is difficult to use as it cannot be seen through the viewfinder. Nor is the viewfinder itself very clear or very accurate, so Marshall was soon using it simply for a rough assessment of the scene, preferring instead to judge the horizontal framing from a pair of arrows carved on top of the camera body.

Lighting

For all these pictures the lighting was simply available daylight. The Widelux has no built-in meter, so Marshall used a handheld semi-spot meter to work out exposures. The camera has a fixed focus and a minimum aperture of f/11. There are three shutter speeds of 1/15sec, 1/125sec and 1/250sec, though the total exposure time is several times greater than this as only a narrow slit of film is exposed at a time. It is possible to handhold the camera at all three speeds, although the faster two are easier.

technical details

Widelux F8 panoramic camera with Fujicolor 400 colour negative film.

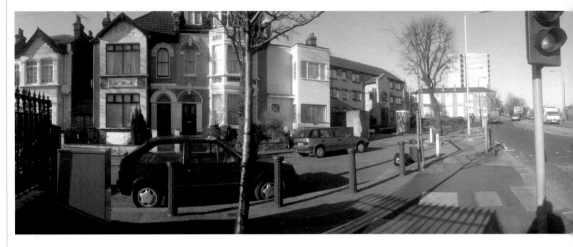

"The main accessory needed was a comfortable pair of shoes. I walked 10 to 15 miles each day and often had to go back to the same location several times."

Peter Marshall

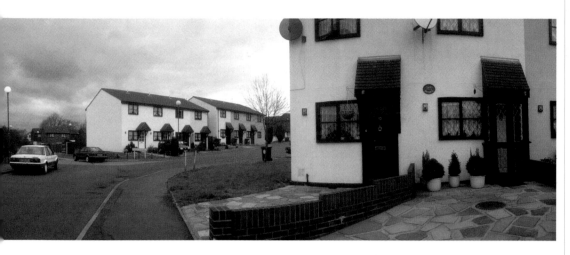

These suburban houses at Chingford Hatch, Essex were photographed as part of the same project. In all, it took Peter Marshall five or six days to complete, exploring the area around the meridian line on foot and searching out suitable viewpoints. 'The main accessory needed was a comfortable pair of shoes,' he recalls. 'I probably walked 10 to 15 miles each day, and often had to go back to the same location several times to get light that worked.' He was inspired partly by the work of Walker Evans. 'He often liked to view buildings frontally and was more concerned with them as cultural rather than aesthetic artefacts,' he explains. 'Like him, I have a great interest in the vernacular.'

technical details
Widelux F8 panoramic camera with Fujicolor 400 colour negative film.

Equipment

For her panoramic pictures, Paula Barr normally uses one of the cameras made by Fuji or the highly specialised Roundshot 220, which takes 360-degree panoramic pictures (she owns one of only six in the world). For a series showing the iconic buildings of New York, she wanted to use the panoramic format – but with a vertical composition. Only a large format camera, equipped with bellows and sufficient ëriseí to avoid badly converging verticals, could give her the flexibility she needed to achieve this. A team of co-operative equipment suppliers helped her to modify a camera to her own specifications, while a specialist lab volunteered to cut sheets of Ilford HP5 film to a 20x8in format and to process them for her afterwards.

Composition

'Scale has always been an important part of my palette. I want things to be large but intimate as well,' says Barr. She spent three weeks on the project, getting the necessary permits to photograph on the New York streets and seeking out the best rooftop vantage points to give her unobstructed views – such as this one of the Chrysler Building. 'The task was to photograph these icons in a manner that was aesthetically and classically pleasing. I wanted to show them in a manner that was timeless,' she says.

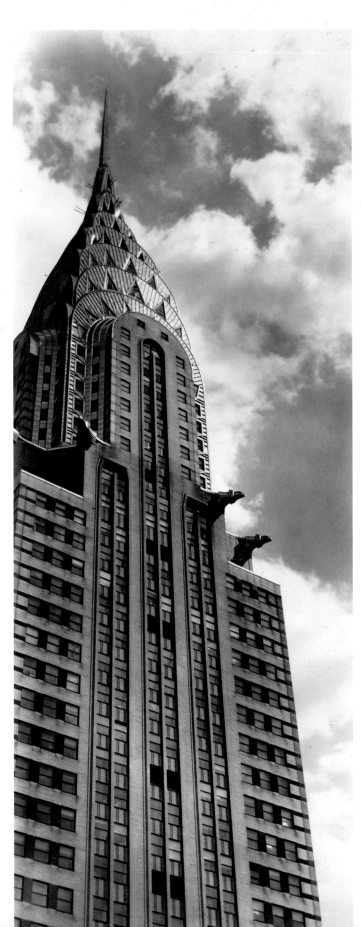

technical details
Specially modified view camera with a Fuji 600C lens. Film was Ilford HP5 sheet film (ISO 400), cut to 20x8in.

'The series was a natural outcome of my ongoing love affair with New York City,' says Paula Barr. 'The images were inspired by Oriental space, Walt Whitman and the masculine energy that goes into building skyscrapers on rock.' Delighted with the results of her experiment, Barr has used the images for a series of fine-art posters which she now sells through her website.

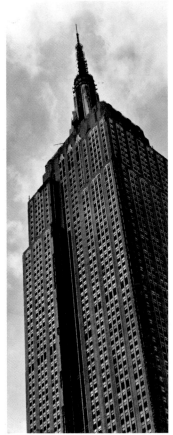

technical details
Specially modified view camera with a Fuji 600C lens. Film was Ilford HP5 sheet film, cut to 20x8in.

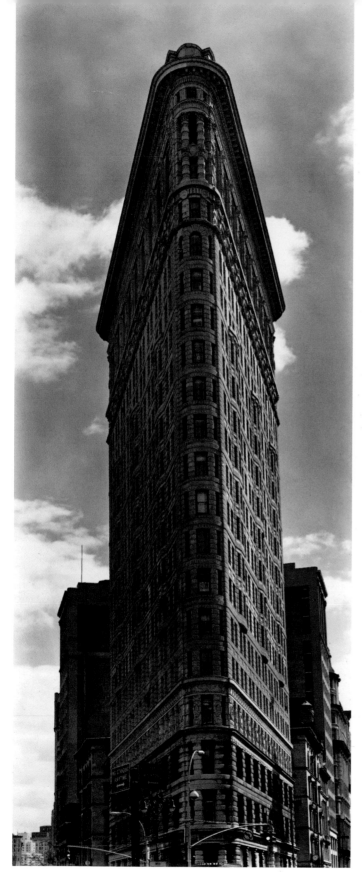

Custom modifications to the camera and lens allowed Paula Barr to keep the verticals straight for this shot of the Flatiron Building. She also used the format to photograph sections of the restored ceiling at Grand Central Station. 'These photographs are the most exciting things I've ever done,' says Barr of the project. 'I've been seduced into the world of large format.'

"I wanted to show these iconic buildings in an aesthetically pleasing, timeless manner."

Paula Barr

technical details

Specially modified view camera with a Fuji 600C lens. Film was Ilford HP5 sheet film, cut to 20x8in.

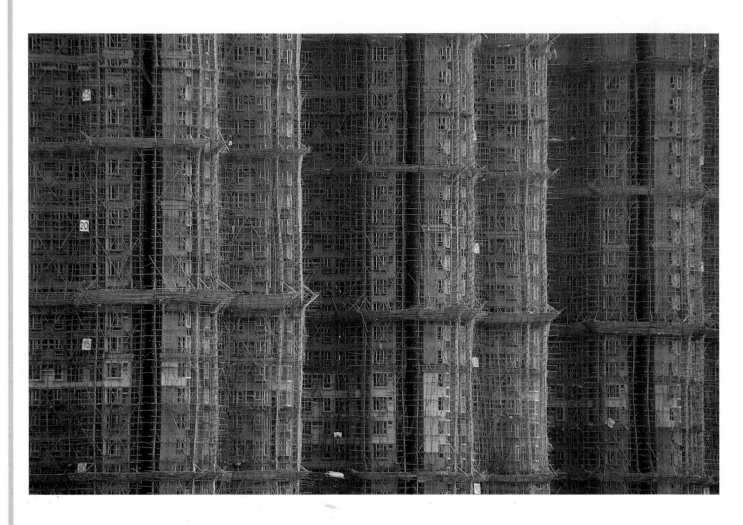

Composition

In many cities high-rise buildings are part of the fabric, but there's no need to show them in their entirety to convey their size and mass. With their strong verticals and geometric5 patterns, they are ideal subjects for abstract shots. Kobi Israel photographed this group of high-rise apartment blocks under construction in Hong Kong, a city where land is so expensive that the only way to build is up.

Technique

Israel used a 300mm telephoto lens on an SLR camera, which allowed him to crop in and isolate a horizontal section of the buildings. A tripod held the camera steady and allowed him to frame precisely. By filling the frame with the wall of buildings and excluding the sky he created an almost abstract composition, enhanced by the repeated patterns of the bamboo scaffolding.

technical details

Canon EOS 5 camera with a 300mm lens. Exposure was 1/250sec at f/8.

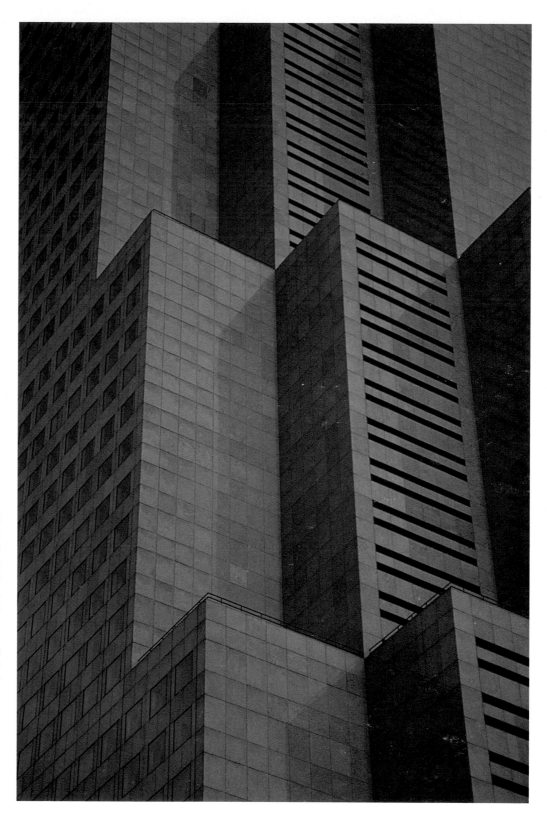

Steve Warble used a 35mm SLR and the telephoto end of a 28-85mm zoom to crop in on a section of the Georgia-Pacific Center building in Atlanta, Georgia. He used available light and dispensed with a tripod, choosing instead to handhold the camera.

technical details
Nikon FM2 35mm SLR with a 28-85 Nikkor zoom lens and Fujichrome Velvia film.

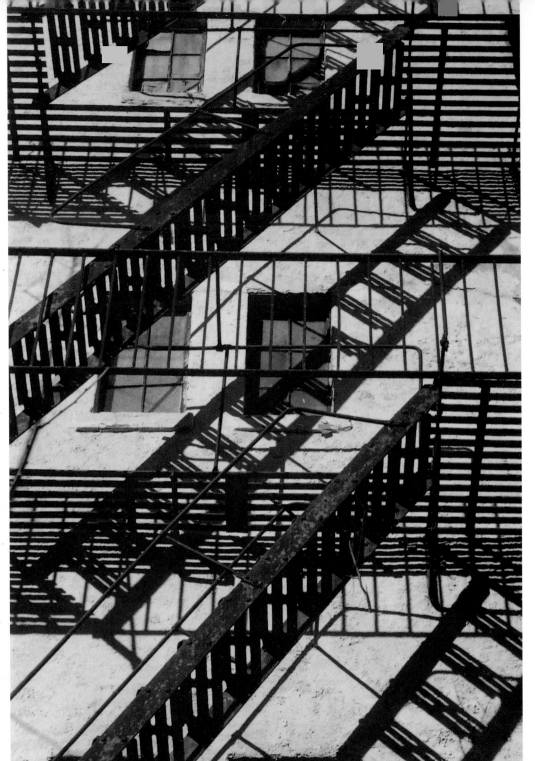

Composition
In search of ëurban geometryí, Kobi Israel was drawn to the intricate patterns of light and shade cast by these metal fire escapes on a street corner in New York City. Using a 35mm camera fitted with a zoom lens, he cropped in tightly on the ladders, shooting in portrait format to emphasise the vertical symmetry of the subject.

Lighting
The picture was taken at noon on a bright summer day, when the sun was directly overhead and creating harsh shadows. Despite the bright conditions, Israel used a tripod; this held the camera steady and helped him to compose with precision. He used a slow black and white film to emphasise the graphic patterns and bring out the detail, and later toned the print a light sepia.

technical details
Canon EOS 5 camera with a 28-105mm zoom lens. Film was Ilford FP4+, with an exposure of 1/250sec at f/8.

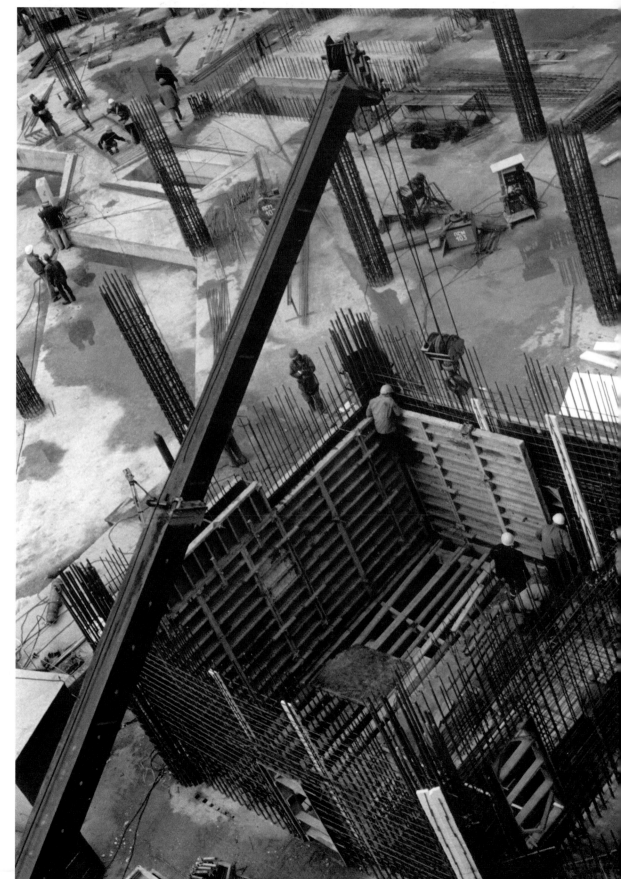

Cities are complex environmental organisms and are constantly renewing themselves – and buildings don't need to be complete before they become interesting. Yuri Avvakumov, influenced by Russian constructivist photography, often finds inspiration in building sites, cranes and scaffolding. To capture this bustling site on 2nd Bretskaya Street in Moscow, he shot from a high vantage point and tilted the camera at an angle, composing so that the crane jib formed a strong diagonal across the frame. The positioning of the workers appeared almost choreographed, as though they were on a stage set rather than a construction site.

technical details
Contax Aria 35mm SLR lens with a 50mm standard lens.

Composition

The Sears Tower is synonymous with the Chicago skyline, and Adam Hoffberg wanted to capture the building in its full vertical glory. He chose to shoot at twilight and used black-and-white film to emphasise its angularity. The problem was finding the right viewpoint, but eventually he settled on an elevated train station 2km north of the tower. The train tracks formed a ëcanyoní that was clear of other buildings and gave an unobstructed view, while the extra height reduced the problem of converging verticals.

Technique

Hoffberg used a tripod-mounted medium format camera and a telephoto zoom, which gave plenty of depth of field and allowed him to crop in relatively tightly. He still had to angle the camera upwards slightly and so couldn't avoid convergence altogether, but it wasn't enough to spoil the shot. To avoid the risk of camera shake, however, he had to time his shots between passing trains. Shooting just after sunset meant that the sky was still bright but that lights were coming on in the buildings, and there was still good shadow detail in the buildings in the foreground.

Printing

Taking the picture was just half the battle: Hoffberg spent 15 hours in the darkroom perfecting the print. He began by cropping unwanted detail from both sides of the frame to produce a highly vertical image with an aspect ratio of nearly 2:1. He used high-contrast paper and painstakingly burned in large portions of the sky, darkening both the left- and the right-hand sides and the top edge of the print but leaving the area around the tower very light, so that the building appeared almost to glow against the evening sky. The effect was exaggerated by burning in the other buildings.

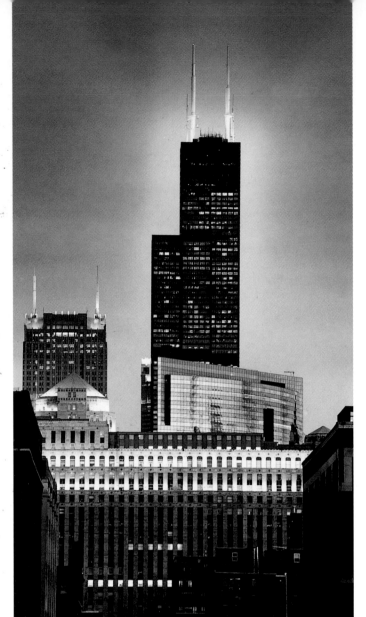

technical details

Mamiya 645 camera with a telephoto zoom lens. Film was Agfapan 100, with an exposure of 1/2sec at f/8.

Tip

It's quite difficult to photograph tall buildings when theyíre surrounded by other high-rises. If youíre close to the building you have to tilt the camera upwards at a sharp angle, and this usually results in converging verticals. If youíre further away and at ground level, it can be hard to find an unobstructed view. The problem can sometimes be solved by searching out an elevated position, such as a roof or a viewing platform in an adjacent building. Look out also for bridges: not only are they higher up, but the road, river or railway that they span will form a corridor clear of other buildings, which may give you the angle you want.

Amused by the pastiche New York architecture of this Las Vegas casino-hotel, Robert Zeichner took this early morning shot with a medium format Hasselblad camera. Usually he takes care to avoid converging verticals, but in this case felt they added to the fun of the picture. Using black-and-white film, he added a yellow filter to bring out the streaks of cloud against the sky. Normally he uses a tripod but on this occasion he shot handheld, bracing the camera against a railing and firing the shutter with a short cable release, which he had left attached to the camera.

technical details
Hasselblad camera with an 80mm Planar lens. Film was Kodak Tmax 100 rated at ISO 240, with an exposure of 1/60sec at f/11, using a yellow filter.

Composition

Andrzej Lech seeks out old and abandoned places in order to create pictures with an air of nostalgia. This shot of New York City was taken from across the water in New Jersey, from an old pier which has since vanished. Lech prints full frame from his negatives, which means that he composes in-camera and does any cropping that is needed before pushing the cable release.

Technique

Lech used a vintage Mamiya Universal Press camera firmly secured on a tripod. The negative size of this camera is 6x9cm but he created a square format by attaching 6x6cm masks over the film plane and the viewfinder. He invariably uses a standard lens. 'I like to record in my photography what my eyes see, instead of what my lens sees,' he says. A standard lens also gives a relatively large depth of field, and in this case the image was needle-sharp from the pole in the foreground to the city skyline in the distance.

Printing and processing

Lech hand-processes all his negatives – from 35mm up to 10x8in format – in Agfa Rodinal developer in a 1:200 solution. His development times are very long – up to 72 minutes for Agfa APX 100 – but this gives him negatives with very fine grain, rich in detail, with deep half-tones and well-defined highlights. He prints on Ilford Galerie paper developed in Bromophen, and sepia tones the images. To complete the process, he immerses the prints in a bath of oolong tea for a few minutes. This stains them to give a rich and creamy antique look.

technical details

Mamiya Universal Press camera with a 6x6cm negative mask and a standard lens. Print made on Ilford Galerie paper, lightly bleached, sepia toned and stained with oolong tea.

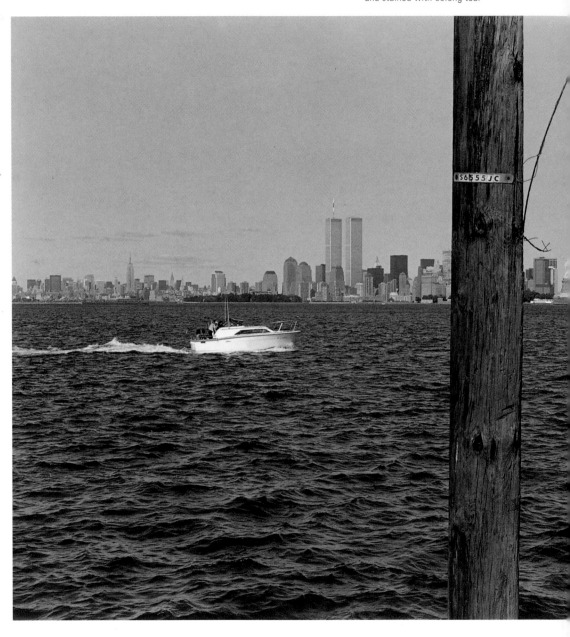

Some of the same buildings featured in the shot opposite can be seen in the distance, but in this urban landscape the skyline is incidental to the composition. The shot was taken in New York Bay Cemetery, a favourite location that Andrzej Lech has been exploring for many years. He used the same Mamiya Universal Press Camera, tripod-mounted, but this time employed the full 6x9cm negative area. The vignetting was created deliberately by shooting with a lens hood attached. Again the negative was given a long development time in Agfa Rodinal to create fine grain and rich tones, and the image printed onto Ilford Galerie paper. Sepia toning, followed by a bath of oolong tea, gave the print an antique patina.

Tip

If you want to give your prints an antique look, reach for the tea caddy. Andrzej Lech bleaches and sepia tones his prints in the darkroom then finishes by immersing them in a solution of tea. Normally he uses China Fujian oolong tea, but also sometimes heavily smoked lapsang souchong for a darker effect. Toning times vary between three and five minutes. The final result depends on the type of tea used, the strength of the solution and the time the print is left to soak.

technical details

Mamiya Universal Press camera with a standard lens. Print made on Ilford Galerie paper, sepia toned and stained with oolong tea.

Composition

Andrzej Lech created this dream-like shot of the New Jersey waterfront with a 10x8in pinhole camera. Pinhole cameras are the simplest of photographic devices, with a pedigree that stretches back to the earliest days of photography. This British-made Robert Rigby model has a turret with three different pinhole apertures, whose settings range from 'short' (with a nominal focal length of 150mm and aperture of f/429) to 'long' (250mm and f/480).

Technique

Lech loaded a sheet of 10x8in film into the holder and exposed it for about five minutes. He then gave the negative a lengthy development time in a 1:200 solution of Agfa Rodinal to produce rich tones and fine grain, before contact printing it onto a sheet of Ilford Galerie paper. To give the print an antique look, he sepia toned it and then left it to soak in a bath of oolong tea, which stained it a rich brown.

Lighting

The picture was taken at dusk, Lech's favourite time of the day. "I don't like full sun – I tend to avoid it and take photographs on cloudy, even rainy, days. I also like taking photographs after it has snowed," he says. "I think that the optimal light for photography is just before sunset. The light then is soft and fills objects nicely."

technical details

Robert Rigby 10x8in pinhole camera, with an exposure of around five minutes. Image contact printed, sepia toned and stained with oolong tea.

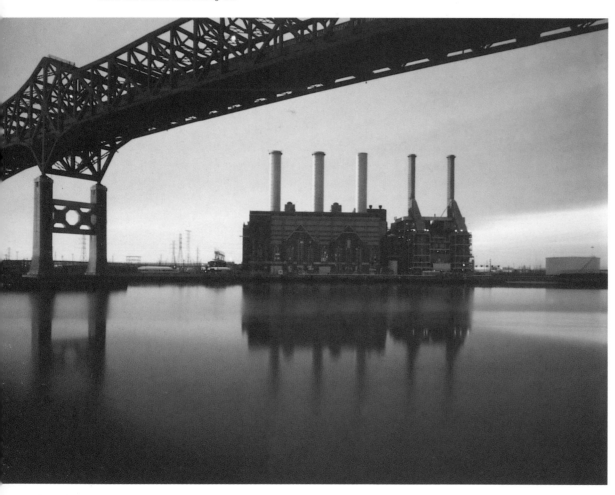

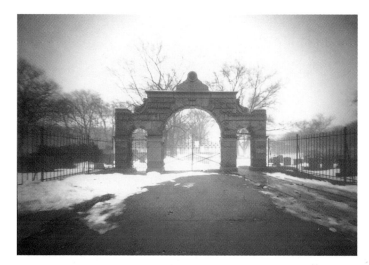

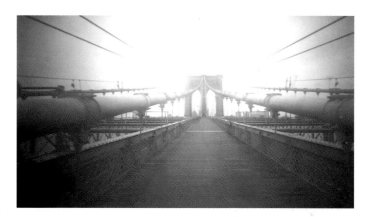

Andrzej Lech made these pinhole images using the same technique as for the main picture, except that he used a smaller, 5x4in Robert Rigby pinhole camera, which accepts a variety of film backs. It has a nominal aperture of f/166 and an angle of view that is nominally 100 degrees in the horizontal plane and 80 degrees vertically. Lech contact printed the 5x4in negatives onto fibre-based paper and created an antique look with a combination of sepia toning and immersion in oolong tea. The bridge was shot in New York, the cemetery gate in New Jersey and the ruined building in Ontario, Canada. All were long exposures – up to five minutes – which meant that a tripod was essential.

technical details
Robert Rigby 5x4in pinhole camera, with exposures of up to five minutes. Images contact printed, sepia toned and stained with oolong tea.

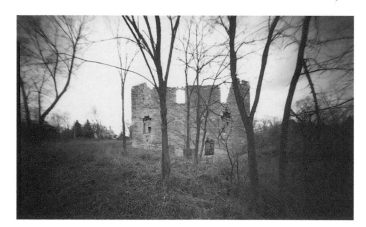

selling your work

The markets for architectural photography are many and varied, and it's essential to approach them with a clear goal in mind. Professionals with an established client base frequently work to order, but picture libraries, publishers, websites and the fine art market all offer opportunities for picture sales.

technical details
Hasselblad 205 camera with a 40mm lens and Fujichrome 64T Pro film.

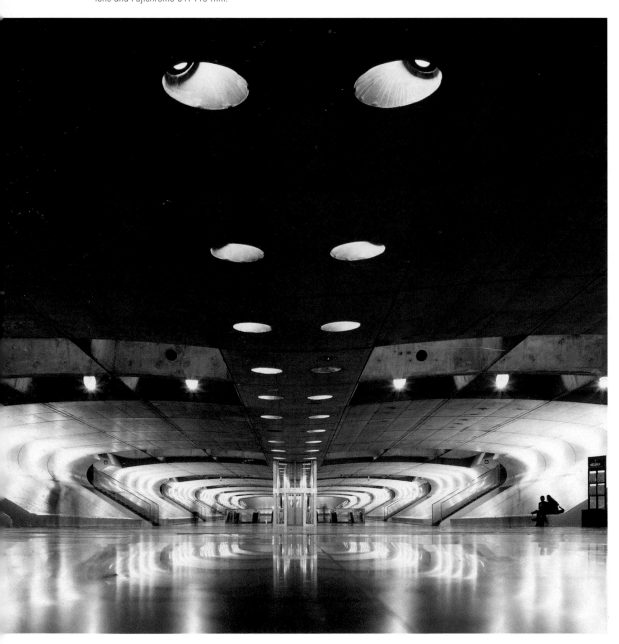

Concept
Michael Reinhard works for many large corporate clients, including some of the leading companies in Switzerland. They keep coming back to him because he produces the kind of striking, graphic pictures they want for their company brochures and annual reports. He also shoots for architects who want their designs to be seen at their best. 'My aim is to create images that are simple, clear and easy to understand but nevertheless are dynamic and invite repeated viewing,' he says. Bold cropping is one of the techniques he uses to achieve this.

Composition
To capture the futuristic design of the Garo do Oriente metro station in Lisbon, Reinhard focused his attention on the concourse ceiling but emphasised the bold patterns by including the shiny reflections in the polished floor. For the shot to work properly he needed the concourse to be empty, so he chose a time of day when there were few people around. However, to give the building a sense of scale, he included a pair of human figures in the lower right-hand portion of the frame, strategically positioned near an intersection of thirds.

'My aim is to create images that are simple, clear and easy to understand but nevertheless are dynamic and invite repeated viewing.'

Michael Reinhard

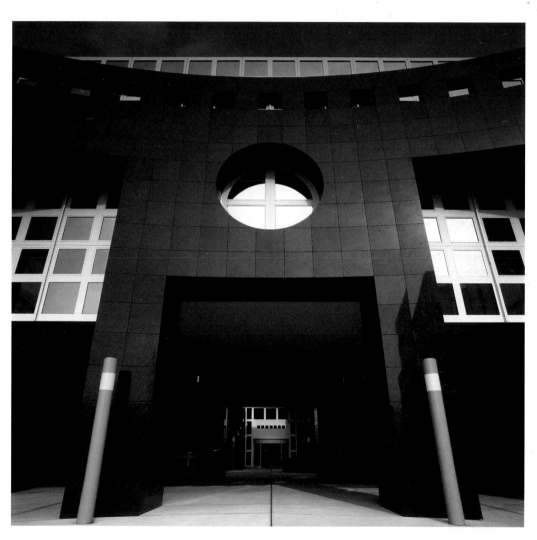

Again Reinhard cropped in tight to produce this bold exterior shot of a Zurich bank building. He deliberately retained the converging verticals, as they created a sense of bulk and power and gave the building an almost monumental quality. He waited until the light of the sky was reflected in the geometric spaces of the windows and heightened the dramatic effect by using Agfa Scala, a black-and-white transparency film that is quite high in contrast. He framed so that the series of archways led the eye deep into the picture, right up to the entrance of the building.

technical details
Hasselblad 205 camera with a 40mm lens and Agfa Scala black-and-white transparency film.

Conception

For Andrzej Lech, it is very important when making his moody black-and-white images that he visualises the picture in its entirety before firing the shutter. He always uses the whole negative area. "I never crop my negatives," he says. "I want to show what I see when I press down the shutter: this is my visualisation of my emotions. The rest – developing the negative, printing and toning and so on – is a simple technical job, routine."

Printing

Routine it may be, but Lech takes great care to present his prints in an aesthetically pleasing manner. He frequently uses vintage cameras which impart their own special flavour to the image, such as the 1950s press camera with which he shot this old New Jersey bar at night-time. He hand-develops his film, typically in a solution of Agfa Rodinal diluted at 1:200, with long development times to ensure fine detail and deep, rich tones. When he prints, he often includes a section of the film surround as a border. This has a twin function: it creates a ready-made frame for the image while also stressing the fact that nothing has been lost at the printing stage.

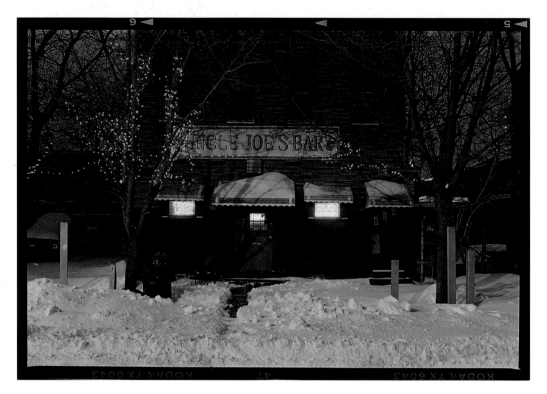

technical details

Mamiya Universal Press camera with a 105mm lens. Film was Kodak Tri-X, with an exposure time of around two minutes. Negative hand-developed in Agfa Rodinal for 48 minutes at 20°C.

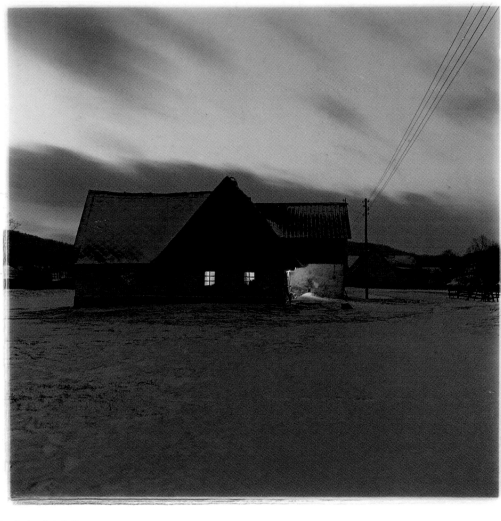

Andrzej Lech uses a variety of enlargers and negative carriers to create framing effects for his prints. For this wintry scene, taken in Poland, he used a carrier which gave uneven edges with a little 'ghosting', imbuing the image with a fine-art feel. Again, he stayed true to his original conception of the shot by printing from the whole negative, with nothing cropped out.

technical details
Rolleiflex twin lens reflex camera with a Tessar 75mm lens. Film was Agfapan 100, with an exposure time of around one minute. Negative hand-developed in Agfa Rodinal for 68 minutes at 20ºC.

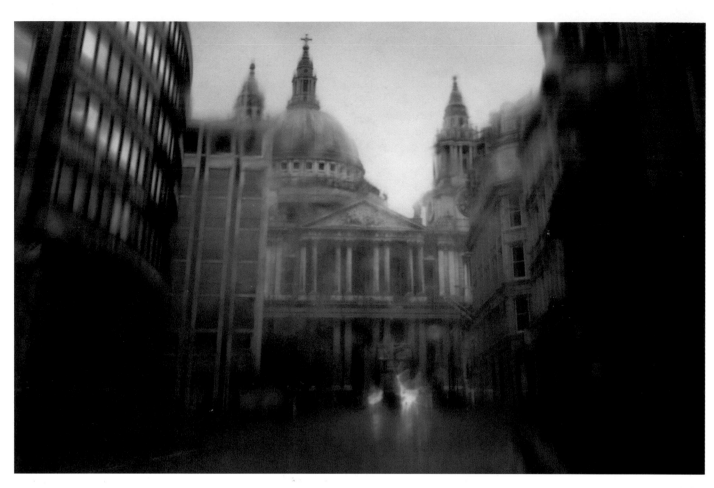

Concept

When shooting to a brief, Philip Brittan gives his clients what they ask for but is always looking for something extra. 'Yes, I produce the straight large format shot that presents the building in its entirety – sharp, with maximum depth of field, good colour balance and no converging verticals,' he says. 'But whenever I shoot architecture I always attempt to give the client a little more. I attempt to capture a few alternative artistic or abstract images that in my view help to present a fuller view of the soul of the building.'

Technique

Brittan has been documenting buildings in London for the past ten years, and is always looking for new ways to portray familiar landmarks. This image of St Paul's Cathedral is an example of his personal work, shot for his own portfolio and for stock. The day was damp and misty and he wanted to convey its 'otherworldly' character. He shot with a short zoom on an autofocus SLR, and deliberately introduced some camera movement as he tripped the shutter. The film was black-and-white Kodak Tri-X, which he processed and printed as normal. However he then bleached the print and re-developed it, before scanning the resulting image and using Photoshop to add the colour toning.

technical details

Canon EOS 1 camera with a 20-35mm zoom and Kodak Tri-X. Image manipulated in the darkroom and in Photoshop.

'Whenever I shoot architecture I always attempt to give the client a little more.'

Philip Brittan

This shot of East India Dock in London's Docklands was another of Philip Brittan's personal projects. He used a medium format camera with a wide angle lens and shot on colour negative film. Once the image was developed, he scanned it into a computer and manipulated it in Photoshop, adding a warm tobacco tone and 'smearing' certain areas to create an ethereal effect. 'With both these images,' he explains, 'I was attempting to convey the essence of a specific environment at a specific moment in time. I will use whatever equipment – 5x4in or plastic toy camera – and whatever technique – straight shot, filters or computer manipulation – I feel is appropriate to capture the moment.'

technical details
Pentax 6x7cm camera with a 45mm lens and Fujicolor 400 Pro colour negative film. Image manipulated in Photoshop.

Composition

Adam Hoffberg's pictures are personal projects and here his subject was texture, especially the textures to be found when buildings start to decay. He set out to illustrate the theme by combining two separate negatives to make a single print, and used a pair of crumbling loft buildings in the old manufacturing district of Brooklyn, New York as his raw materials. Both subjects were rich in texture: one a wall on which the paint was starting to peel, the other a door adorned with signs, keyholes, rivets and pieces of metal. To capture this in detail, Hoffberg opted for medium format with its relatively large negative size.

Printing

Composite prints require a lot of darkroom work. "When printed together, the negatives will combine in a way that is hard to predict from each printed separately," says Hoffberg. "Careful experimentation is needed to determine the right combination of density and contrast for each negative. The cumulative effect of exposing the paper twice is also very likely to make it go too dark." He used high-contrast paper to draw out the maximum texture, and burned in the edges of the smaller image to make it stand out more clearly. This created a frame effect, with the smaller image seemingly transparent and floating on top of the larger one.

technical details

Mamiya 645 camera with Agfapan 100 black-and-white film. Composite print made by combining two separate negatives.

For this shot of a decayed industrial building (set in a 19th century warehouse district of New York) Adam Hoffberg used a 50mm perspective control lens on a medium format camera, with the front element adjusted upwards to keep the verticals parallel. The building was shaded by the taller structures that surrounded it so the light was indirect and even, meaning that only minimal burning-in was required when he came to make the print. He used a low-contrast paper to retain detail in both the highlights and the shadows, and gave the print a warm brown cast by first processing it in warm-tone developer and then toning it in a solution of concentrated selenium.

technical details

Mamiya 645 camera with a 50mm perspective control lens. Film was Agfapan 100, with an exposure of 1/4sec at f/16. Print processed in warm-tone developer and selenium-toned.

Approach

Don't be afraid of shooting familiar sights. These are often the ones that sell the best – to magazine and book publishers, calendar companies and advertising agencies. However, unless you already have contacts in the publishing industry, selling your work can be a daunting task. This is where a partnership with a stock picture library can be invaluable. Picture libraries act as agents, marketing and selling images and splitting the proceeds with the photographer, typically on a 50/50 basis. Work must be of the highest standard before a library will consider handling it, and most libraries prefer large and regular submissions. There are many that specialise in architectural subjects: BAPLA, the British Association of Picture Libraries and Agencies (www.bapla.org.uk), is a good place to start.

Preparation

Clive Minnitt was visiting friends in Hong Kong during the handover to China in July 1997. For eight of the ten days he was there the weather was appalling, with constant heavy rain and high humidity, which meant that protecting his camera gear was his biggest priority. On the two dry days he was able to photograph the famous view of the city's skyscrapers from Victoria Peak. Probably every visitor to Hong Kong takes a snap of this scene but, as one of the great sights of the world, quality images of it will always be in demand.

Lighting

Minnitt spent four hours on each of the two days shooting pictures from the Peak, as the changing light conditions subtly altered the scene. This one was taken at his favourite time of the day, the brief period of 'crossover' light in the early evening when lights come on in buildings and in the streets but the sky still has some light in it. This normally lasts only for half an hour or so before the light fades altogether, but it can give some subtle and atmospheric lighting effects. Minnitt used a 35mm SLR mounted on a tripod and fired the shutter with a remote shutter release.

technical details

Canon EOS 1 camera with a 28-80mm lens and Fuji Velvia film. Tripod-mounted camera fired by remote shutter release.

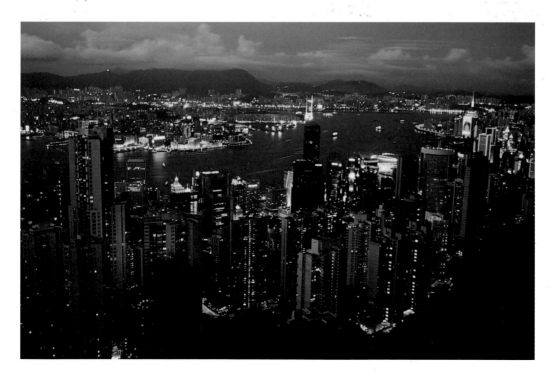

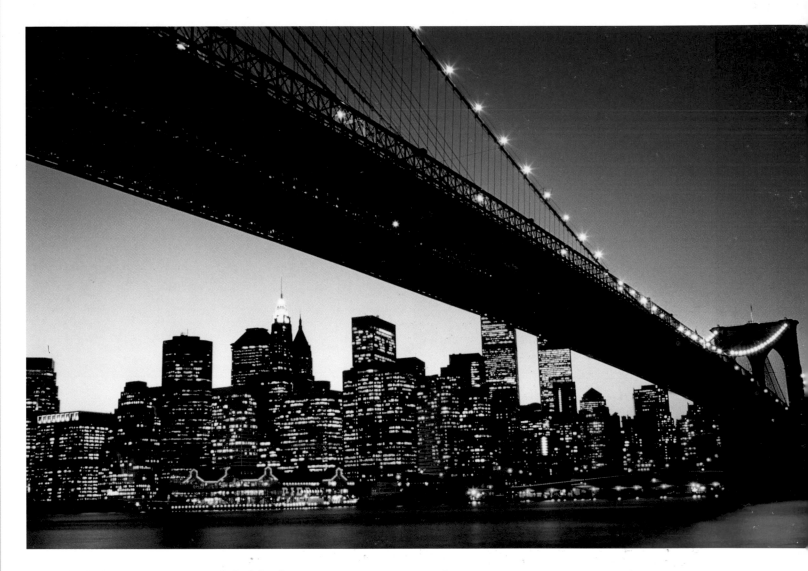

Another classic city view, again photographed in available evening 'crossover' light. Clive Minnitt captured the Brooklyn Bridge in New York at dusk, when the illuminated buildings of Lower Manhattan provided a spectacular backdrop. He tried out shots at both dusk and dawn to make the most of different lighting conditions. This one came from the last of his four visits to the same location.

technical details
Canon EOS 1 camera with a 28-80mm lens. Fuji Velvia film and polarising filter. Tripod-mounted camera fired by remote shutter release.

Applications

An incredible number of photographers now have their own websites, from keen amateurs to top-flight professionals. It's relatively easy to get on the internet and a well-designed website can be an invaluable marketing device, pulling in individual clients and attracting a wide range of professional picture users. This book itself is an example of how effective the internet can be: many of the photographers whose work is featured were initially contacted via their websites, as the images displayed on them were judged to be suitable for use in a book on architectural photography.

Marketing

A website acts a shop window for your talents and you should publicise its existence as widely as possible. Include your web address on your letterheads and business cards and in any brochures and marketing materials you may use. In cyberspace itself, it's important to establish links to as many other relevant sites as you can. Think about businesses you could approach which might be willing to incorporate click-through links from their sites to your own, and investigate user groups with a shared interest in either architecture or photography. Sites with a local focus – such as those run by schools, colleges and community associations – can also provide useful leads.

Design

The internet is a global resource and professionals such as Mario Guerra use it as a marketing tool to advertise their work internationally. The design of Guerra's site is relatively straightforward, with a limited number of pages and a small selection of images on each page. However, each page is calculated to demonstrate his expertise in a specialist subject area, and lets potential clients know immediately whether his work is likely to fulfil their particular requirements. The pages are constructed so that a click on any of the thumbnail images brings up a larger version of the picture, which can be viewed in greater detail. A page containing brief biographical details of the photographer and a 'Contact' click-through to his e-mail address complete the package.

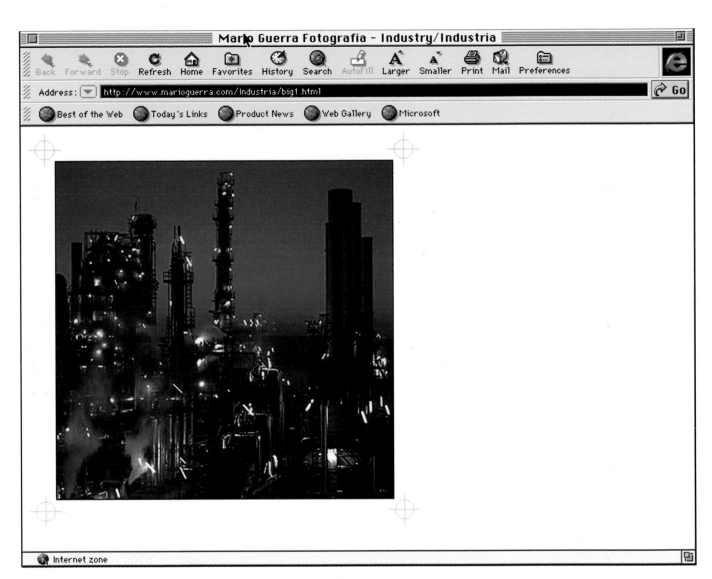

Mario Guerra Fotografia – Industry/Industria

Back Forward Stop Refresh Home Favorites History Search AutoFill Larger Smaller Print Mail Preferences

Address: http://www.marioguerra.com/Industria/big1.html Go

Best of the Web Today's Links Product News Web Gallery Microsoft

Internet zone

Content

You can pay a professional web designer to set up your site or, with a modicum of technical knowledge, you can set one up for yourself. Sites are inexpensive to maintain and can be updated regularly with a fresh supply of images.

Before starting, think carefully about the purpose of the site. Do you want it simply to display your images in the hope of attracting commissions, or do you want to use it more proactively to sell images directly to potential customers? Photographers such as Robert Zeichner, Paula Barr and Gregoire, for example, all use their sites to sell fine art black-and-white prints, individually and in limited edition sets, direct to collectors. Kobi Israel and Steve Warble, on the other hand, have sites which function more as stock libraries, containing galleries of images that can be browsed by potential buyers such as publishing companies or corporate clients. Take a look at some of the sites listed on the following pages to see how effective the different approaches can be.

However you design your site, remember to keep it clean and simple to navigate. Nothing is more calculated to deter potential users than sites which are cluttered with unnecessarily complex click-through windows or 'amusing' features that take forever to download. Image files should also be kept relatively small and low-resolution for ease of viewing.

glossary

Ambient light
General term for any existing lighting, natural or artificial, not provided by the photographer.

Archival processing
Print and processing procedures aimed at achieving the most stable, and therefore most durable, image possible.

Aspect ratio
Ratio of the width of an image to its height. A 35mm film frame has an aspect ratio of 3:2, a computer screen one of 4:3.

Barn doors
Device resembling a pair of shutters which fits over a lamp or flash head to control its light output.

Bellows unit
Concertina-type accessory, mostly used with large format cameras, which fits between lens and camera body to allow a range of focusing adjustments.

Bracketing
Practice of making additional exposures above and below the indicated meter reading to increase the chances of accurate exposure.

Burning
Darkroom technique in which areas of the print are darkened by increasing the exposure time.

Colour temperature
Scale used to measure the colour content of ambient light, expressed in Kelvins (K). The higher the Kelvin figure, the bluer the light: the normal colour temperature for tungsten film is 3200K, for example, while for daylight types it is 5500K. A colour temperature meter can be used to match film type to lighting or to determine whether colour correction filters are necessary.

Converging verticals
Visual effect – usually unwanted – which makes vertical lines appear to meet towards the top of the frame. It occurs when the camera is tilted and the film plane is no longer parallel to the subject.

Conversion filters
Colour correction filters used to compensate for differences between the colour balance of film and the colour temperature of the light source. For example, an orange 85B filter is used to correct daylight on tungsten film, while 80A and 80B blue filters are used to correct tungsten light sources on daylight-balanced film. Paler filters can be used to fine-tune transparency film.

Dark slide
Plastic or metal sheet that protects a sheet film holder or magazine but is removed before exposure.

Dodging
Darkroom technique in which areas of the print are masked off during exposure so that they print lighter.

Exposure latitude
The inbuilt tolerance of a film to exposure errors. Black and white films and colour negative films have a much wider latitude than colour transparency films.

Fibre-based paper
Black-and-white printing paper which usually gives rich, warm tones.

Filters for black and white
Coloured filters can be used with black and white film to affect contrast. Red and yellow filters, for example, deepen blue skies and make clouds stand out more clearly. Filters usually reduce the amount of light entering the lens, and exposures should be increased to compensate.

Grey card
Exposure aid which reflects 18 per cent of transmitted light, most closely approximating to an 'average' exposure reading.

Incident light reading
Exposure reading used to measure the light falling onto a subject rather than – more commonly – the light reflected off it. The meter is held at the subject position and pointed back towards the camera.

Neutral density filter
Filter that reduces the intensity of the light reaching the film without affecting any of the colours. Allows the use of larger apertures in bright lighting conditions.

Panoramic camera
In true panoramic cameras, a long strip of film is exposed via a moving slit while the lens pivots around a vertical axis during exposure. Some cameras offer a panoramic option, but this is often done simply by masking off part of a normal film frame, giving a much smaller image.

Perspective control lens
An adjustable lens for 35mm and medium format cameras, used to correct converging verticals in a similar way to the rising front of a

large format camera. Also known as a tilt and shift lens.

Photoshop
Adobe Photoshop is a powerful and versatile graphics software package. Once photographs have been scanned into a computer, it can be used to electronically retouch them or manipulate them to create a wide range of effects.

Pinhole camera
A simple device consisting of a box with a small hole pierced in it, through which the image is formed and the exposure made. There is no lens and so no need to focus, but this means that compositions have to be done 'blind'.

Polarising filter
Neutral grey filter which cuts out polarised light, saturating colours and eliminating reflections from water and other non-metallic surfaces.

Pulling
Method of lowering the nominal speed of a film by reducing its development time, normally used to reduce contrast.

Pushing
Method of increasing the nominal speed of a film by increasing development time. Used to increase speed or enhance contrast.

Reciprocity failure
The law of reciprocity says that a short exposure of a bright image should give the same result as a long exposure of a dim image. In practice, however, this law 'fails' when using colour film at very long exposures, giving rise to unpredictable colour casts.

Reflected light reading
Meter reading taken from the camera position, with the meter pointed towards the subject.

Reflector
Used to bounce light back on to a subject to fill in shadows and even out lighting. There are many commercially available types but reflective materials such as polystyrene, silver foil and white card can also be used.

Rising front
Adjustable front element of a large format camera which allows the lens to be raised, correcting converging verticals by keeping the subject parallel to the film plane.

Rule of thirds
Classic compositional device. Visualise the frame split by lines into three equal portions, both vertical and horizontal, forming a grid. Placing the main subject on any of the four points where these lines intersect helps to balance the composition and can also help to highlight a subject.

Spirit-level
Used for ensuring that the camera is level. Some tripods have them built in, as do some panoramic cameras. Also available as a hotshoe-mounted accessory.

Spot metering
Exposure reading taken from a small (and usually the most important) part of the subject to ensure that it is correctly exposed.

Tilt and shift lens
See Perspective control lens.

Tripod
Essential for architectural photography: buy the best model you can afford. Should be strong enough to hold the camera absolutely rigid during long exposures, but should also be adjustable for low-angle shots. Some high-end models come with a built-in spirit-level.

Tungsten lighting
Tungsten lamps contain a fine metal filament which glows when heated. Can be used for both hard and soft lighting, or as a modelling light for flash.

View camera
Large format camera, most commonly of 5x4in or 10x8in format, although others do exist. There are two basic types: monorail and baseboard, depending on their construction. Sometimes also known as a field camera.

Vignetting
Effect that gives a dark border around the edges of the frame, especially in the corners. Can be caused accidentally by badly-fitting filters or lens hoods or created deliberately to create an antique effect.

Zone system
Method for determining the tonal range of prints, developed by photographers Minor White and Ansel Adams.

David Arraez was born in France in 1963 but moved to England at the age of five, then to Venezuela at 14. Leaving high school in 1982, he returned to the UK to study photography. He began his career by assisting a number of different photographers in London and Paris, before turning full-time freelance in 1990.
David Arraez Studio, Le Bourg de Lieury, 14170 L'Oudon, France.
Tel: +33 (0)6 10 85 85 96
e-mail: contact@arraez.com
www.arraez.com

Yuri Avvakumov is an architect, artist and designer. In the 1980s he was a leading figure in the USSR's 'paper architecture' movement and participated in exhibitions in Moscow, the US and in cities across Europe. In the 1990s his architectural work was exhibited at the Venice Biennale, the Dutch Architectural Institute in Rotterdam and the State Museum of Architecture in Moscow, as well as in Washington, Paris, St Petersburg, Cologne, Venice and Milan. He has been organising exhibitions at the Moscow House of Photography since 1996 and took up photography professionally in 1999.
Goncharnaya nab, 3-24 Moscow, 109172 Russia.
Tel: +7 095 9157213
e-mail: utopia@aha.ru
www.24photo.ru

Paula Barr is a New York-based artist and photographer. She is the creator of the world's largest photograph, officially recognised by *The Guinness Book of Records*: a 10ft x 74ft panorama made with archival glass tiles, which adorns a hospital wall in Mobile, Alabama. She has held numerous exhibitions, has published her work widely and has won many awards. She has carried out a long list of public art work commissions and her photographs are held in a number of public collections, including the Museum of Modern Art and the Library of Congress.
526 West 26th Street, 9G, New York, NY 10001, USA.
Tel: +1 212 691 9482
Fax: +1 212 691 9567
e-mail: pbarr@pipeline.com
www.paulabarr.com

Björg, based in New York City but originally from Reykjavik, studied fine art photography at the School of Visual Arts in New York. She specialises in architectural and interior photography and has a broad range of clients. Her photographs, featured widely in magazines and books, have also been exhibited in numerous New York galleries and profiled on CNN.
Björg Photography, 447 Fort Washington #61, New York, NY 10033, USA.
Tel/fax: +1 212 740 6310
e-mail: bjorg@bjorgphoto.com
www.bjorgphoto.com

Philip Brittan is a self-taught professional photographer, following a career previously spent in academia. He has worked in many areas, including food, still life and portrait photography, but his main areas of interest are the built environment, including architecture and interiors, and landscapes, especially abstracts. In his creative work he is turning increasingly to digital techniques.
Philip J Brittan Photography, 43 Lea Bridge Road, London E5 9QB, UK.
Tel: +44 (0)20 8806 1908
E-mail: philipj@brittanphotography.com
www.brittanphotography.com

Carlos Cezanne was born in Oporto, Portugal in 1959 and was educated at German schools there and in Wiesbaden. He began working at an advertising agency in Oporto in 1991 but soon left to set up his own photographic studio, taking fashion and product shots. He began specialising in architecture and interiors in 1995, working with interior decoration magazines. In 1997 he published a book of Portuguese interiors (*Porto Ambientes*), followed in 1999 by a second (*Norte Ambientes*), and in 2000 he began collaborating with *wallpaper** magazine. He is currently working on further book projects.
Tel: +351 22 205 2321
Fax: +351 22 200 1769
e-mail: tevef@mail.telepac.pt
www.ccezanne.com

Michael Conroy served his apprenticeship at a local studio in Perth, Australia, working his way up from the darkroom to shooting major advertising jobs and assisting in London and Vancouver. He returned to Perth to go it alone, and shot everything from cereal packets to hotels. A passion for interesting architecture pushed him in the direction of architectural photography, which he now enjoys as a continual challenge.
Silvertone, 21 Wittenoom Street, East Perth 6004, Western Australia.
Tel: +61 8 92256336
Fax: +61 8 92213784
e-mail: studio@silvertone.net.au
www.silvertone.net.au

Koen van Damme graduated in photography and film from the Ghent Academy of Arts in 1991. He worked as a freelance photographer for

contacts

advertising agencies and corporate clients but his main interest lay in photographing buildings, especially modern ones. In 1996 he became a full-time architectural photographer, working for architects, estate agents, magazines and publishing companies. His book on office blocks was due for publication in late 2001.
Voordelaan 12, 9831 Deurle (Sint-Martens-Latem), Belgium.
Mobile: +32 477 40 78 13
e-mail: mail@koenvandamme.be
www.koenvandamme.be

Gregoire is the pseudonym of Gregory C Benoit. He lives in Iowa, where he teaches English literature at college level, but he travels and photographs mostly in New England. His primary photographic influence has been Ansel Adams.
e-mail: greg@gregwa.com
www.gregwa.com

Mario Guerra, born in Rome in 1964, has been a professional photographer since 1985. Besides architecture, he covers corporate, industrial, interior, art, still life, reportage and portrait photography. His clients based in Italy and the US and include some of Italy's biggest chemical and petrochemical companies. He supplies work to museums and art galleries and has completed a wide range of

personal reportage projects, which have taken him all over the world. His photographs have appeared in publications such as *Zoom*, *Reflex*, *La Repubblica*, *Corriere della Sera* and *Il Mesaggero* and he has held several exhibitions of his work. He teaches courses in industrial photography and lighting at the European Design Institute of Rome and the Univerity of Rome.
Mario Guerra Fotografia, Via Michele di Lando 11, 00162 Rome, Italy.
Tel: +39 0644252261
Fax: +39 0644117805
e-mail: mg@marioguerra.com
www.marioguerra.com

Morten Heiselberg studied photography at Berkshire College of Art and Design and since 1995 has worked as a freelance, supplying pictures for magazines, books and calendars. He specialises in still life, architectural/interior and industrial subjects, and also enjoys landscape and travel photography. He lives in Bergen, Norway, and has exhibited his pictures in Norway, France and the UK.
Leitet 4C, 5018 Bergen, Norway.
e-mail: hohei@heiselberg.no
www.heiselberg.no

Adam Hoffberg is a self-taught fine art photographer who has been

creating monochrome architectural images since 1994. He specialises in the aesthetics of texture and decay, and his subjects range from Roman ruins to abandoned American factories. Influences include his education in mathematics and geometry and the work of Eugene Atget, Margaret Bourke-White, Michael Kenna and Judith Turner. He works as a housing policy analyst for the US government and lives in Washington DC.
e-mail: adam@hoffbergphoto.com
www.hoffbergphoto.com

Angelo Hornak has been an architectural photographer for the past twenty-five years, taking it up professionally after studying architectural history at Oxford. Besides running his own picture library, he has illustrated and contributed to many books, including histories of Durham, Canterbury and St Paul's cathedrals, York Minster and Brighton Pavilion. He has published two books of his own: *Balloon over Britain* (1991) and *London from the Thames* (1999). He lives in London, and can be contacted through BAPLA (the British Association of Picture Libraries and Agencies).

Kobi Israel was born in 1970 and studied at the Academic School of Art in Tel Aviv and the New York Film Academy. He has supplied numerous

CD sleeve photographs to Israel's leading record labels and his award-winning travel pictures have appeared in a number of books and magazines. In 1997 he staged a solo exhibition, *Cities That Never Sleep*, which was shown in Tel Aviv and on the internet.
PO Box 5353, Tel Aviv, 61053 Israel.
Tel: +972 53 26 66 63
e-mail: to@kobi-israel.com
http://www.kobi-israel.com

William Jackson fell in love with the photography in the 9th grade, took all the yearbook pictures at his high school and was chief photographer on his college newspaper at Mercy College, Detroit. He studied photography for a year at the Center of Creative Studies in Detroit before a desire to see the world led him to spend 21 years in the air force. He kept up his photography as a hobby and photographed weddings and real estate, and in 1996 opened a studio and gallery on a military base in Germany. He recently sold the gallery and retired from the air force and now lives in Albuquerqe, New Mexico.
e-mail: williamwjackson3@yahoo.com
www.photographic-designs.de

Andrzej Lech was born in Poland in 1955 but has lived in Jersey City, New Jersey since 1989. He studied fine art photography at the School of Visual Art

in Ostrava in the Czech Republic and has been exhibiting since 1981. His work is held by the Museum of Modern Art in Lodz and the National Museum in Wroclaw, and by Icon Pictures in New York. He had a solo exhibition during the 8th International Month of Photography FotoFest 2000 in Houston, Texas, and is currently working on a book of photographs of the New York Bay area.
Andrzej Lech Photography, On the Way Gallery, 111 First Street, Jersey City, New Jersey 07302, USA.
Tel: +1 201 656 2984
Fax: +1 201 795 5421
E-mail: andrzej@andrzejlech.com
www.andrzejlech.com

Peter Marshall is a photographer, teacher and writer on photography whose work has appeared since 1973 in numerous books, magazines and exhibitions. He currently writes the photography area of internet content guide About.com. His photographs can be seen on his own and other websites. The main focus of his photography is London — structures, people and events.
31 Budebury Road, Staines, Middx TW18 2AZ, UK.
Tel: +44 (0)1784 456474
e-mail: petermarshall@cix.co.uk
http://petermarshallphotos.co.uk
http://londonphotographs.co.uk

Clive Minnitt was born in Lincolnshire and lives in Bristol. During his six years as a professional architectural and landscape photographer, he has travelled the globe and worked for clients as diverse as Rolls Royce and the Forestry Commission. He has won a number of awards and has seen his work featured in many publications and exhibitions.
Clive Minnitt Photography, 15 Longfield Road, Bishopston, Bristol BS7 9AG, UK.
Tel: +44 (0)117 924 8152
e-mail: clive@minnitt.com
www.minnitt.com

Igor Palmin, born in 1933, is one of Russia's most distinguished architectural photographers. He has published several books, the most celebrated of which, *Russian Modernist*, has been printed and reprinted in Russia, France, Italy and the US. His work has been exhibited at the Russian Museum, the Tretyakov Gallery and the Museum of Architecture, among others.
www.24photo.ru/eng/info_ipalmin.htm

Scott Pearson is an award-winning freelance photographer with a diverse portfolio ranging from food and travel to interiors and architecture. He shoots for corporate, stock, advertising and magazine clients and his pictures have appeared in many publications, including *Showboats International*, *Yachting Magazine* and *National Geographic*. He began his career as an underwater photographer with the Cousteau Society, and now lectures extensively on environmental issues. He also produces an annual calendar of underwater photography, with part of the proceeds being donated to marine research. He is based in South Florida and is planning to publish his first book of photographs in 2002.
Scott Pearson Photography, 133 Intracostal Circle, Tequesta, FL 33469, USA.
Tel: +1 561 748 1346
e-mail: spearson@gate.net
www.scottpearsonphoto.com

David Plowden was born in Boston in 1932 and educated at Yale. He studied with Minor White and worked as an assistant to O Winston Link, before in 1962 setting out to document in words and pictures the vanishing history of small-town America. Over the course of a long and distinguished career he has held nearly two dozen exhibitions of his work and has won many awards. He has published 15 books of his own and illustrated many more, has contributed to countless magazines and has taught at universities in Chicago, Iowa, Baltimore and Michigan. His work is held in the permanent collections of some 19 US museums and galleries, and in 1995 the Beinecke Rare Book and Manuscript Library at Yale University agreed to acquire his entire archive of photographs, notebooks and published work for the Yale Collection of Western Americana.
c/o Jennifer Unter, RLR Associates, 7 West 51st Street, New York, NY 10019.
Tel: +1 212 541 8641
Fax: +1 212 541 6052
e-mail: Junter@RLRAssociates.net
www.davidplowden.com
www.people.virginia.edu/~bhs2u/david -p/david-p.html

Michael Reinhard has been a freelance photographer and film-maker since 1982. He has an international client list, which includes many leading Swiss companies. He specialises in landscape, architecture, industry and construction.
Michael Reinhard Photography, Steinradstr. 29, 8704 Herrliberg, Switzerland.
Tel: +41 (0)79 218 18 22
e-mail: photo@michaelreinhard.com
www.michaelreinhard.com

Mark Surloff was inspired to take up photography by the pictures of Ansel

Adams and Edward Weston. He set up a small darkroom and started off with a Nikkormat camera before moving up through medium to large format cameras. He had the good fortune to study with Ansel Adams at his workshop in Yosemite National Park. Eventually he sold up his chemical business and took the plunge into professional photography.
Mark Surloff Photography, 1655 NE 115 St., North Miami, Florida 33181, USA.
Tel: +1 305 899 8450
e-mail: mark@surloff.com
www.surloff.com

Steve Warble owns Mountain Magic Photography, based in Elgin, Illinois, which specialises in stock sales and décor photography. His work has been featured in scores of magazines, calendars and books and in museum and environmental displays. His interest in photography is the result of a lifetime spent backpacking; he has travelled on foot in parks and wilderness areas throughout North America.
Mountain Magic Photography, PO Box 5762, Elgin, IL 60121, USA.
Tel: +1 630 365 2207
e-mail: warbs@webtv.net
www.agpix.com/stevewarble

Jerome Whittingham is passionate about photography and has been taking pictures for most of his life. His images have appeared in print and on the internet, and he is also pursuing fine art ambitions.
686 Beverley Road, Hull, Yorkshire, HU6 7JH, UK.
Tel: +44 (0)1482 858899
e-mail: jerome@pholio.softnet.co.uk
www.soft.net.uk/pholio

Robert Zeichner was born and grew up in New York City. He studied advertising and visual communications at Pratt Institute and subsequently worked for 30 years in the film and television industry. He writes on photography for a variety of publications, including View Camera magazine and several websites, and over the past six years has held a number of one-man shows in his adopted home state of Michigan. He has recently been inducted into the Art Photography League of Flint.
Robert A Zeichner Fine Art Photography, 15574 George Washington Drive, Southfield, Michigan 48075-3038, USA.
Tel: +1 248 552 0152
e-mail: info@razeichner.com
www.razeichner.com

Specialist suppliers

Corfield
www.gandolficorfield.co.uk

Robert Rigby
www.bobrigby.com/html/pinhole.html

Fuji Widelux
In Europe, the Widelux is marketed as the Hasselblad XPan, a collaboration between Hasselblad and Fuji Photo Film Co. Fuji markets another panoramic camera of its own, the Fuji GX617.
www.fujifilm.co.uk/professional
www.xpan.com

Acknowledgements

Thanks are due to Sarah Jameson, who did the picture research and tracked down so many excellent contributors; to Brenda Dermody and Austin Carey, who designed the book and did the illustrations; and to editor Angie Patchell, who came up with the idea in the first place and who supported and encouraged me throughout. Most of all, though, I'd like to thank all the photographers who so generously contributed their time, their expertise and their images.